Mounted Oriental Porcelain

MOUNTED ORIENTAL PORCELAIN

Sir Francis Watson

International Exhibitions Foundation

International Exhibitions Foundation

1700 Pennsylvania Avenue, N.W.

Washington, D.C. 20006

Library of Congress Catalogue Card Number 86-81585
I S B N 0-88397-088-0

Designed by Homans | Salsgiver
Typeset in Monophoto Van Dijck
and printed on *Huntsman Velvet*
by Balding + Mansell Limited, Wisbech, England

Photography credits

Ken Cohen, New York City [cat. no. 29]
Bruce C. Jones, Rock Point, New York [cat. no. 28]
Eric Mitchell, Philadelphia Museum of Art [cat. no. 25]
Don Williamson [cat. no. 46]
Photographs of other objects in this exhibition catalogue
have been provided by the individual lenders

COVER:
Lidded Bowl with Mounts
Japanese porcelain with English gilt metal
mounts. The J. Paul Getty Museum, Malibu,
California (cat. no. 9).

LENDERS
TO THE EXHIBITION

Alexander & Berendt, Ltd., London
The Art Institute of Chicago
The Ashmolean Museum, Oxford, England
Cheng Huan Esq.
The Cleveland Museum of Art
Cooper-Hewitt Museum, the Smithsonian Institution's National Museum of Design
The Detroit Institute of Arts
Didier Aaron, Inc., New York City
The Fine Arts Museums of San Francisco
The Fitzwilliam Museum, Cambridge, England
The Frick Collection, New York City
The J. Paul Getty Museum, Malibu, California
Kunstbibliothek Berlin mit Museum für Architektur Modebild
 und Grafik-Design, SMPK
Lee Collection, courtesy the Massey Foundation
 and the Royal Ontario Museum, Toronto
Dr. and Mrs. Walter Liedtke, New York City
The Metropolitan Museum of Art, New York City
Museum of Fine Arts, Boston
National Gallery of Art, Washington, D.C.
Philadelphia Museum of Art
Private collection
Private collection, through Rosenberg and Stiebel, New York City
Private collection, through the Royal Ontario Museum, Toronto
The Toledo Museum of Art
Victoria & Albert Museum, London
The Walters Art Gallery, Baltimore

Participating Museums

The Frick Collection, New York City
The Nelson-Atkins Museum of Art, Kansas City, Missouri
Center for the Fine Arts, Miami, Florida

Trustees of the International Exhibitions Foundation

CONTENTS

ACKNOWLEDGMENTS

The International Exhibitions Foundation takes great pleasure in presenting this splendid exhibition of mounted oriental porcelain. The forty-five masterworks featured in the exhibition are among the finest and rarest examples of this exotic art form, a combination of East and West, which reached its height during the eighteenth century in France.

The exhibition is the result of our long and fruitful association with guest director Sir Francis Watson, former director of the Wallace Collection in London, who selected the works and wrote the text to the accompanying catalogue. Special recognition is also due Anthony Derham, director of the Japan Society, Clare le Corbeiller of the Metropolitan Museum of Art, and Gillian Wilson of The J. Paul Getty Museum, for their invaluable assistance to Sir Francis at every stage of this endeavor.

To the more than twenty-five private and institutional lenders in this country and abroad, we extend our heartfelt thanks for their willingness to share their treasures. We are particularly indebted to The J. Paul Getty Museum for its generous support.

We are grateful as well to the directors and staffs of the participating museums, who have cooperated in every way to make the exhibition a success.

The scholarly publication could not have been realized without the expertise of editor B. J. Bradley, designer Katy Homans of Homans|Salsgiver, and printer Guy Dawson of Balding + Mansell, all of whom deserve our sincere appreciation.

Finally, I extend my warm thanks to the staff of the International Exhibitions Foundation: Linda Bell, Lynn Kahler Berg, Stanley Dawson, Gregory Allgire Smith, and Sarah Tanguy, for attending to the many details involved in organizing the exhibition and its tour, as well as Colette Czapski, Bridget Goodbody, and Diane Stewart.

ANNEMARIE H. POPE
President
International Exhibitions Foundation

PREFACE

In the winter of 1980–1981 I organized an exhibition, "Chinese Porcelain in European Mounts," for the China Institute in America in New York City. It was, I believe, the first exhibition devoted exclusively to mounted oriental porcelain ever to have been held. To embark on another exhibition on such a recondite subject so soon after the first calls for some justification. This exhibition is very different in scope from the earlier one, which was restricted to mounted Chinese porcelain and laid special emphasis on porcelain mounted in Paris in the mid-eighteenth century, when the fashion for such things was at its apogee and the art was carried to the greatest heights of technical accomplishment and design. In the current exhibition, not only has Japanese mounted porcelain been included alongside Chinese but a small group of other mounted materials, such as lacquer and Isnik pottery, is shown as well. There is, too, a greater emphasis on pieces mounted elsewhere than Paris—in England, Holland, Germany, and even Southeast Asia—for the taste for mounting rare objects was by no means exclusively a European one. The Chinese themselves are known to have practised the art as early as the seventh century A.D. At the other chronological end of the history of the art is, I believe, the claret decanter designed by the English architect William Burges for his own use. This decanter is the last piece of Chinese porcelain to have been mounted in Europe as a serious attempt to accommodate an oriental object to contemporary Western taste rather than as a deliberate pastiche or reproduction of eighteenth-century models.

In preparing this exhibition I have incurred many obligations. First and foremost, I must express my gratitude to Mrs. John A. Pope and her staff at the International Exhibitions Foundation, who have worked so hard in assembling the exhibition. Among individuals, I owe a special debt to Anthony Derham, the learned director of the Japan Society, who spent many hours explaining to me the niceties of oriental porcelain and identifying those mounted examples included in the exhibition. If there are errors of description, topography, or date in the catalogue, they are due to my failure to understand his lucid expositions. My god-daughter Clare le Corbeiller of The Metropolitan Museum of Art proved, as always, a mine of abstruse information about both the porcelain and the silver mounts. Gillian Wilson and her two assistants at The J. Paul Getty Museum, Gay Nieda and Charissa Bremmer-David, allowed me to pester them constantly with requests for references not available to me in New York, while Carol Dowd did the same with references at the library of The J. Paul Getty Center for the History of Art and the Humanities. Likewise, David Cohen and Libby Spatz placed the Photographic Archives of the Center at my disposal by long-distance telephone almost as vividly as if I had been in California myself. As with the earlier

exhibition, the analytical index of references to mounted porcelain in the *Livre-Journal* (sales book) of Lazare Duvaux prepared by Robert K. Sturtz proved of the utmost value. Ted Dell generously allowed me to see his drafts of the entries for the mounted porcelain in The Frick Collection prepared for his forthcoming catalogue. Alan Fausel provided me with most valuable information about the pieces lent from the San Francisco museums. M. Daniel Augarde was so kind as to bring to my attention the important references to mounted porcelain shells in the Radix de Sainte-Foix sale of 1782, and Everett Fahy discovered an important piece of mounted porcelain for me that otherwise I would not have known about. Lady Stewart and her staff furnished me with valuable material relating to Beckford's art collection. I am also grateful to Barbara J. Bradley and Tam Curry, my editors, who gave a coherence and polish to my catalogue that it otherwise would have lacked.

Finally, and perhaps most importantly of all, my debt to my own earlier catalogues of mounted porcelains and especially to the Getty museum catalogue written with the collaboration of Gillian Wilson and Anthony Derham extends frequently to verbatim quotation.

FRANCIS WATSON

INTRODUCTION

For Cheng Huan

1.
Léon de Laborde, *Glossaire Française du Moyen Age . . . Précédé de l'Inventaire des Bijoux de Louis, duc d'Anjou* (Paris, 1872), p. 107. Translation: A bowl made from a stone called porcelain with a border of gilded silver and enamel. On the border are three of our coats of arms and three panels of fluting decorated with small serpents' tongues, pearling, and granulations, all of silver-gilt.

2.
De Laborde, *Glossaire Française*, p. 215. Translation: an ewer of porcelain.

3.
The work is fully discussed by Arthur Lane in "The Gaignières-Fonthill Vase: A Chinese Porcelain of about 1300," *The Burlington Magazine* CIII (April 1961): 124–132.

This introduction summarizes much longer discussions of the history of the practice of placing oriental porcelain in European mounts. The interested reader should consult the introductions to the following richly illustrated sources for further information: Watson 1970, Watson 1980, and Watson, Wilson, and Derham 1982 (see Bibliography for complete citations).

The practice of presenting rare, precious, and exotic objects in metal mounts has a long history in both Europe and the East. The earliest mounted piece known to me is a glass cup (sometimes thought to be of Western origin) in the Shôsôin treasury at Nara in Japan, which had already been mounted as a goblet on a foot of Chinese silver when it was included in the presents given by the Empress Dowager Komyo to the Todiji Temple in 756 A.D. The mounts probably date from considerably earlier. There is no record of any exotic objects being so mounted in Europe till many years later. A number of pieces of Chinese porcelain acquired by the sultans in the early sixteenth century and today preserved in the Topkapi were embellished in Turkey with gold, gilded metal, and even occasionally precious stones. These pieces mostly came from Persia, which had long traded in porcelain with the Chinese.

Perhaps the earliest reference to oriental porcelain being set in metal mounts of European make occurs in the inventory of the *bijoux* (treasures) of Louis duc d'Anjou drawn up in 1379–1380:

> 714. *Une escuelle d'une pierre appelee pourcelaine borde d'argent dore et esmaille. Et ausur le dit bort iii ecussons de nos armes et y a iii fretels d'argent dorez a perles a petit grenex et sur chascun fretel une petit langue de serpent.*[1]

An object of some size, it is elsewhere described as an *escuelle pour fruiterie* (fruit bowl). How unfamiliar porcelain was at that time is evident from the phrase "a stone called porcelain," a term that reappears a few years later in the will of Jeanne d'Evreux, queen of Navarre.

By the opening decade of the following century, greater familiarity enabled the compilers of the inventories of the duc d'Anjou's two brothers, Jean de Berry and Charles V of France, to refer merely to *une aiquierre de pourcelaine ouvree* (an ewer of porcelain decorated with undercutting; probably a vessel of Yuan ware like the Gaignières-Beckford vase mentioned below) or to *un pot de pourcelaine*.[2] None of these objects have come down to modern times in identifiable form, although one piece from the period, unhappily deprived of its fourteenth-century mounts today, survived with its mounts intact down to the middle of the nineteenth century. This is the famous mounted vase presented by Louis the Great of Hungary to Charles III of Durazzo in 1381.[3] It derives its name, the Gaignières-Beckford vase, from two previous owners—Rogier de Gaignières, an eighteenth-century French *archéologue* (antiquarian), and William Beckford of Fonthill, an English collector who owned the vase during the first half of the nineteenth century. Each left pictorial evidence of its appearance, complete with its mounts (see cat. no. 46),

4.
For an illustration, see Watson, Wilson, and Derham 1982, p. 4, fig. 4.

5.
The most important surviving assemblage of such things is the Treasury of St. Mark's in Venice, much of which recently toured the United States in "The Treasury of San Marco," an exhibition that was on view in New York, Los Angeles, and Chicago during 1985–1986.

6.
An anonymous Flemish painting in the National Gallery, London, dated c. 1520, shows a group of Chinese porcelain objects on display on a buffet. A detail is reproduced in van der Pijl-Ketel 1982 (see Bibliography for complete citation), p. 32. For this reason, it is highly unlikely that Bellini intended to represent European faïence copies of Chinese wares, as has sometimes been suggested. The gods had to have the best.

7.
Some idea of the quantity of porcelain reaching Europe even at this early date is revealed by the recent underwater exploration of the Dutch carrack, *Witte Leeuw*, sunk by the Portuguese in the harbor of St. Helena in 1613. Some 22,000 pieces of blue-and-white porcelain have been brought to the surface. A great deal of evidence on the size of shipments of porcelain to Europe is contained in Volker 1952 (see Bibliography for complete citation). Yet for the most part, only inferior porcelain, made especially for export, came to Europe. The grander Imperial wares were exported only on rare occasions.

which seem to have remained intact until Beckford's death in 1844. The vase itself is now in the collection of the National Museum of Ireland in Dublin.

The earliest piece of Chinese porcelain to survive together with its European metal mounts is a celadon bowl of the Ming dynasty brought back from the Near East by Count Philip von Katzenellenbogen between 1438 and 1444 and mounted before 1453 in silver-gilt as a covered cup.[4] Such objects were always few in number. No doubt they were mounted in precious metals (Piero dei Medici had *una choppa de porcellana leghata in oro*, a porcelain cup mounted in gold) because of their rarity, high value, and exotic character, just as antique cameos and objects of crystal and other hard stones had been given settings of gold and other precious metals in the treasuries of the great cathedrals of the West.[5] This practice led later to the destruction of their mounts.

In the painting *The Feast of the Gods* by Giovanni Bellini and Titian (National Gallery of Art, Washington, D.C.), which dates from about 1514, the gods are eating from Chinese porcelain rather than gold plate, clear evidence that the two materials were regarded as of equal rarity and importance. Porcelain was certainly displayed side by side with the gold plate on the buffets of the wealthy.[6] Likewise in Mantegna's *Adoration of the Magi* (J. Paul Getty Museum, Malibu, California), which dates from about a decade earlier, Balthazar is presenting in a blue-and-white Ming bowl his gift of gold to the infant Christ.

With the opening of the sea route to the Far East by the Portuguese and Spanish in the sixteenth century, Chinese porcelain—generally blue-and-white Ming wares—began to reach Europe in greater quantities, although Japanese porcelain did not arrive until considerably later. During this period, Lisbon was the principal center for the purchase of oriental curiosities. Nevertheless, this new familiarity did not make oriental porcelain any less popular with European collectors. Before the end of the sixteenth century, Philip II of Spain owned about 3000 pieces of Chinese porcelain, a number of which were mounted. That impassioned collector of the exotic, Emperor Rudolph II, had an only slightly smaller collection in Prague and at Schloss Ambras in the Tyrol. And Queen Elizabeth I of England owned enough porcelain to use for eating from at banquets.

The intrusion of the Dutch into the Far Eastern carrying trade after the highly successful Dutch East India Company was founded in 1602 was violently resented by the Portuguese and Spanish, but it greatly increased the availability of Chinese porcelain in Europe.[7] By the middle of the seventeenth century, Amsterdam had displaced Lisbon as the principal European market for the purchase of Chinese goods of all sorts, especially porcelain, lacquer, and textiles. Japanese goods arrived later; the first big consignment of Japanese porcelain appeared on the Dutch market only in 1660. Even after the creation of true (hard-paste) porcelain in Europe at Meissen in 1709, oriental porcelain retained its prestige for a long period although its popularity gradually waned, especially after the appearance of *porcelaine de France* in 1769.

During the seventeenth century, the taste for Chinese porcelain (and other

8.
A reconstruction of such a room was part of the traveling exhibition "The Splendor of Dresden, Five Centuries of Collecting." Organized by the National Gallery of Art in Washington, D.C., the exhibition was also seen in New York and San Francisco during 1978–1979.

9.
The most readily accessible account of the embassies is contained in H. Belevitch-Stankevitch, *Le Goût Chinois en France au Temps de Louis XIV* (Paris, 1910; reprint Geneva: Slatkine Reprints, 1970).

oriental artifacts such as lacquer, silk, and wallpaper), hitherto the prerogative of the very rich, became increasingly popular in Western Europe. Rooms exclusively devoted to the display of porcelain (China cabinets or *Porzellenzimmer*) were widespread. They were lavishly decorated with blue-and-white porcelain on every architectural feature—chimney pieces, cornices, skirting boards, and on numerous brackets attached to walls.[8] Most European countries—England, Germany, Holland, Italy, and especially France—engaged in the practice of setting oriental porcelain in metal mounts. But in France it enjoyed a greater success than anywhere else. By the middle of the eighteenth century, Paris had become the main center for the production of mounted oriental porcelain.

A striking example of the French passion for orientalism was the creation by Louis XIV in 1670–1671 of the so-called Trianon de Porcelaine in the park at Versailles. This luxurious garden pavilion, a gift to his reigning mistress, the marquise de Montespan, was covered on the exterior with faïence tiles painted to imitate Chinese blue-and-white porcelain, a color scheme that was extended to the decoration of the interior. Unhappily, the faïence tiles did not stand up to the rigors of a northern winter, and the building had to be torn down after a bare six years' use. A lesser, but no less significant, witness to the taste may be seen in the king's own daily habit of taking his breakfast cup of bouillon from a bowl of Chinese porcelain mounted with two handles in the form of entwined serpents of gold.

But a far greater stimulus to the fashion of *lachinage* in France (the word *chinoiserie* did not enter the French language until the middle of the nineteenth century) was the arrival in 1684 and 1686 of two Siamese "embassies" at the court of Versailles, bringing immense quantities of Chinese goods—chiefly porcelain, lacquer, metalwork, and silk—as presents to Louis XIV, his family, and his court. Neither delegation was, in fact, a diplomatic mission but a trade deputation arising from the difficulty France had encountered in obtaining permission to open a trading post in China itself. Siam provided a suitable staging post in the long sea voyage from China to Europe. The sight of a long procession of "mandarins," in their exotic native costumes with tall conical hats, arriving at the Palace of Versailles and performing the kowtow at the feet of the Sun King in the Grand Galerie was sensational, widely described, and depicted in many media.[9]

On fashionable French society the effect was electric. The demand for Chinese goods rose dramatically. Within a few years, the number of Parisian shops dealing with *lachinage* increased from two to twenty. Masked balls *à la chinois*, at which oriental costumes were insisted upon, became the rage. When an Englishman, Dr. Martin Lister, visited Paris in 1698, he commented in his diary on the number of houses he visited where collections of oriental porcelain were on display. The king's eldest son, the Grand Dauphin, a passionate art collector, was especially proud of his 368 pieces of oriental porcelain, 64 of which had come as presents from the Siamese ambassadors.

Many of the Grand Dauphin's porcelains, although not of course the Siamese gifts, were mounted with silver-gilt. A few had mounts of gilt bronze, which was to become the usual way of mounting Far Eastern porcelain in the next century. The reasons for this important change from silver to the less costly gilt-bronze mounts

10.
On the development of the rococo style, see Fiske Kimball, *Le style Louis XV, Origine et Evolution de Rococo* (New York: Dover Reprints, 1970), passim.

11.
How successful this acclimatization was is amusingly illustrated by François Boucher's design for the tapestry *La Foire Chinois*. In both the oil sketch in the Musée de Besançon and the finished tapestries, a Chinese merchant is shown offering for sale a porcelain vase already fitted with gilt-bronze mounts, a complete anachronism.

are not entirely clear. But two factors were paramount: the increasing availability of oriental porcelain and the rise of the rococo style.

By the end of the seventeenth century, oriental porcelain was reaching Europe in large quantities. The pieces were no longer given precious metal settings in Europe because of their rarity and costliness, as they had been a century earlier. In the late sixteenth century, Lord Burghleigh's mounted porcelain (see cat. no. 4) was still certainly intended for display on a sideboard along with his gold and silver plate to impress visitors, as had been the custom in Europe since the Middle Ages. But by 1700, with thousands of pieces of oriental porcelain entering the port of Amsterdam each year, such things were no longer so costly that only the very rich could afford them. Porcelain began to be mounted merely so it could be used decoratively in a domestic setting, not for ostentatious display on a high-tiered sideboard or as a rare exotic in a *Künstkammer*. And many collectors could not afford the extravagance of mounts of precious metals for mere interior decoration.

The other, and perhaps more important, factor that contributed to the abandonment of precious metals in favor of gilt bronze for mounts was the rise of the rococo style. Architectural historians have dated the incipient signs of the style in France to 1699,[10] when the rage for oriental works of art, stirred up by the visits of the Siamese ambassadors, was still very high in Paris. An increasing familiarity with oriental porcelain and lacquer (paintings were rarely imported at this time) also played its part in the evolution of this new anticlassical style by acquainting Europeans with asymmetry and unfamiliar types of perspective. By consciously or unconsciously adopting certain features of Far Eastern art, the rococo style made that art more readily acceptable in France. The influences were reciprocal.

From 1720 onward, gilding was increasingly used in French domestic interiors. The change from silver to gilt bronze for mounts was certainly intended to make the porcelain blend more readily with the decorative schemes of such interiors with their wealth of gilding. In a similar manner, the forms of the mounts themselves, with their C-scrolls and acanthus sprays, echoed the forms of the carved wall paneling. It was no longer the intention to emphasize the exotic character of the porcelain but rather to make the pieces conform more readily with a French setting, to modify their foreign appearance by giving them a quasi-French character.[11]

The persons chiefly responsible for giving the mounts this Gallic character were the *marchands-mercier*. Members of this guild played such a fundamental role in shaping eighteenth-century French taste, especially the taste for oriental goods, that a brief outline of their functions is necessary. The word *marchand-mercier* is untranslatable, for the profession did not exist in England or in any country other than France. Literally translated, it means "merchant-merchant," a tautology. The *marchands-mercier* combined the roles of antique dealer, china merchant, jeweler, frame maker, interior decorator, and dealer in light fixtures and hearth furniture. They made nothing themselves but employed other artisans to work on their ideas and designs. In their *Encyclopédie*, Diderot and d'Alembert referred to them as *faiseurs de rien, marchands de tout* (creators of nothing, sellers of everything). Their role was as inspirers of taste and fashion rather than as craftsmen who actually

12.
Thermidore (an anonymous novel published in 1748), vol. 1, p. 15. Translation: He does in France what the French do in America, he exchanges trinkets for gold ingots.

13.
Savery de Brustalons, writing of the *marchands-mercier* in 1691 in the *Dictionnaire de Commerce ecc.*, described one of their functions as supplying *curiosités propres pour l'ornement des appartmens* (curios appropriate for decorating apartments).

14.
A limited edition of *Le Livre-Journal de Lazare Duvaux Marchand-Bijoutier, 1748–1758*, was printed in Paris in 1873, edited and with a long introduction by Louis Courajod (reprint, Paris: F. de Nobele, 1965). After Courajod edited it, the manuscript disappeared.

made works of art. They provided the world of fashion with the chic and the up-to-date. A contemporary, writing of the *marchand-mercier* Hébert, remarked wittily: *Il fait en France ce que les Français font en Amérique, il donne des colifichets pour lingots d'or.*[12]

To embody their designs and ideas the *marchands-mercier* employed others: *ébénistes* and *menuisiers*, *fondeurs*, *doreurs*, *ciseleurs*, and artisans from numerous other guilds. The *marchands-mercier* marketed the results and were ingenious in devising ways of adapting rare and exotic materials, especially those from the Far East, to the decoration of the houses of the Parisian society of the day.[13] As far as mounted porcelain is concerned, these middlemen bought the oriental porcelain, generally on the Dutch market. *Fondeurs*, *ciseleurs*, and *doreurs* then executed the mounts, usually after the designs created by their *marchands-mercier* employers. Actual designs for mounts for porcelain are rare. Certain drawings included in this catalogue (see cat. nos. 49–52) were almost certainly made after the mounted objects they represent. Others may merely be records of existing pieces prepared for artisans to copy (see discussion, cat. nos. 49–52).

Fortunately, the *Livre-Journal* (sales book) of one of the most important of these *marchands-mercier*, Lazare Duvaux, survives for the period 1748–1758,[14] the peak years of the fashion for oriental porcelain. Literally hundreds of examples of mounted porcelain passed through his shop, Au Chagrin de Turquie, in the ten years covered by this precious document. All the influential figures in Parisian society came to this shop in the fashionable rue Saint-Honoré. The marquise de Pompadour, one of Duvaux's most regular clients, purchased more than 150 pieces of mounted porcelain in the relatively short period covered by the sales ledger. Louis XV and his queen also patronized Duvaux's shop. Many important figures at the Court of Versailles were his clients, as were foreign royalty, visiting Englishmen, German princes, and wealthy Russians, in fact, the entire European world of fashion.

The sales book is a mine of information about the subject of mounted porcelain, as the numerous quotations in the catalogue show. It describes a wide variety of mounted porcelain types, gives their prices as well as the prices of unmounted oriental porcelain and the cost of the mounts. We learn from this book who collected mounted porcelain (almost all his clients), and it even casts some faint light on the names of the obscure artisans who made the mounts.

Yet the *fondeurs-ciseleurs* and *fondeurs-doreurs* who made these delightful and often exquisitely wrought mounts, with a few rare exceptions, remain names in the sales register and nothing more. We know a little of the style of Duplessis from the work he is known to have done for the Sèvres porcelain factory. But he never signed a mount for porcelain. The Caffiéris, father and son, produced a number of signed works in gilt bronze. But they never seem to have signed a porcelain mount (although they are known to have made them), probably because they regarded such work as too trivial to warrant a signature. And later in the century, a few *fondeurs* such as Saint-Germain or Osmond signed occasional works but never the porcelain mounts. Even Gouthière's rare mounts for oriental porcelain are known only because they were engraved, not because they were signed. The same applies to Thomire's mounts for *porcelaine de France*, which are never signed but occasion-

15.
François Boucher, a painter living in an essentially bourgeois milieu, owned several pieces of mounted porcelain, a fact known from the sale of his collection after his death. At least one of these pieces, a potpourri of mounted gray crackle celadon porcelain appears in more than one of his paintings. He also designed mounts for vases of either marble or porcelain.

ally documented. *Fondeurs* such as Aze and Godille are described in contemporary documents as specializing in *les garnitures de porcelaine et autres vases précieux* (mounts for porcelain and other precious vessels), but we have no means whatever of identifying their work today. The sad truth is that these artisans were not artists in the modern sense but merely craftsmen who had no individual existence outside the quotidian labors of the workshop, obeying the orders and executing the designs of others. This is not to say, of course, that many were not craftsmen of the highest skill.

From being collected by a small group of exceedingly wealthy princes and aristocrats even in the seventeenth century, the taste for mounted porcelain became widespread in Parisian society in the middle years of the eighteenth century.[15] But the taste evolved slowly. Hundreds of examples of mounted porcelain of all sorts were sold by Lazare Duvaux in the ten years covered by his sales ledger. Yet Duvaux was only one of a large number of *marchands-mercier*, many of whom dealt in mounted porcelain, with shops in the fashionable quarters of Paris. For example, the *marchand-mercier* Gersaint's trade card states that he, a friend and patron of Watteau, specialized in oriental goods and *lachinage*. So did Julliot, whose name appears on so many eighteenth-century sales catalogues, as the sign of his establishment, Au Curieux des Indes, indicates. There were many others.

Yet paradoxically, the first time that a piece of mounted porcelain appeared in the Paris sale room was in 1744, just four years before Duvaux's *Livre-Journal* opened. And only three years earlier, a piece of mounted porcelain had been bought for the French Crown for the first time. The taste for these things seems to have burst into full bloom with remarkable suddenness.

Another factor, neither economic nor aesthetic, made a powerful contribution to the popularity of mounted porcelain and *lachinage* generally in France in the mid-eighteenth century: the growth of a widespread interest in the political and religious organization of the Chinese Empire. The complex story of this factor in the growing appeal of mounted porcelain can only be briefly touched on here. It arose from the reports sent back annually by the Jesuit missionaries charged with converting the "Celestial Empire" to Christianity. Valuable as these *Lettres Edéfiantes* were in informing Europeans about matters such as the Chinese methods of making porcelain or manufacturing silk, they nevertheless contained a strong element of misleading propaganda. The Jesuits were anxious to persuade Europeans, and especially their sponsors in Rome, that their missionary efforts were far more successful than was in fact the case. They naturally made Chinese religion and politics the subject of many of their *Lettres*. In these communications the missionaries suggested that the country was a monolithic Confucian state administered by philosophers and ruled by a philosopher-king. There was some excuse for the suggestion, because the Jesuits' contacts were chiefly with the mandarin class who were all, like the emperor himself, Confucians.

Confucianism, the Jesuits suggested, by its own nature was very close to Christianity already. Only references to its "Founder" and his "Divine Nature" were omitted from its teaching through lack of knowledge of Western history.

16.
For a discussion of the effects of the Jesuit reports in Europe, see Nicholas Trigault (1577–1628), *The China That Was: China as Discovered by the Jesuits at the Close of the Sixteenth Century*, translated from the Latin by Louis-Joseph Callagher (Milwaukee, 1942).

17.
Many of these pieces were certainly designed deliberately for mounting in Europe with metal lids, bases, thumb pieces, and the like. Such types of porcelain are much more rarely found with French mounts (cat. no. 15 is an exceptional example). The Dutch are known to have sent standard patterns of useful wares to the Far East as models.

18.
For an excellent example of this practice, see the lidded pot discussed in Watson, Wilson, and Derham 1982, pp. 74–76.

A little more support for their missionary efforts, they implied, and the Middle Kingdom would become a Christian empire and fall into the lap of the Roman Catholic church. Although this was very far from the case, as events proved, the Jesuits' ideas were taken up with enthusiasm in secular Europe (but not in Rome), where many thinkers were seeking a substitute for Christianity in some sort of deism. Voltaire, perhaps the most influential intellectual of the period, became an enthusiastic spokesman for what he imagined to be Confucianism. His most successful play *L'Orphelin de la Chine* (1755) had as its subtitle *Les Morales de Confucius en Cinq Actes*. In his *Essai sur les Moeurs* (1756) he wrote, "the organization of their [the Chinese] Empire is, in truth, the best in the world," and he declared the Far East to be "the cradle of all arts to which the West owes everything." European sovereigns, he recommended, should imitate humbly the beneficent rule of the emperors of China.[16]

Mme. de Pompadour, one of the most ardent collectors of mounted oriental porcelain, and her friend François Quesnay, an economist and agricultural expert sometimes referred to as *le Confucius Européen*, were deeply committed to beliefs such as Voltaire's. They carried their admiration so far that in 1756 they persuaded Louis XV to plough the first furrow at the beginning of spring in order to promote a fruitful French harvest. This rite was an imitation of the age-old ceremony for the same purpose performed at each vernal equinox by the emperor of China at the Altar of the Earth. The irony of the most skeptical and sophisticated of European monarchs performing a primitive fertility ritual in the middle of the Age of Enlightenment was no more lost on his contemporaries than it is on us today. But against such a philosophic background, the appeal of *lachinage* in France is easy to understand.

In France at this time oriental porcelain was usually mounted for decorative purposes in a domestic setting. The pieces had no other function: the ewers were not used for pouring liquids, the vases were not intended to hold flowers, nor the bowls to contain food. Only the potpourris had a marginal function in perfuming the room, surely a part of the decorator's function (see cat. nos. 16, 25, 31). In other countries the practice was different. In Holland, where Chinese porcelain was especially popular, mounts were almost always applied to oriental porcelain for functional reasons, so they could be used as tankards or teapots (see cat. nos. 8, 10, 15).[17] It was the same in Germany and in other countries. But in France, unhesitatingly, the spout and handle of a wine pourer would be cut off before mounting so that it would in no way resemble a European vessel but become a nonfunctional object with no purpose other than as decoration.[18]

Lazare Duvaux's sales ledger ends in 1758. To the last, he was selling large quantities of oriental porcelain mounted in the rococo style. But by 1756 a turn in the tide of taste was becoming apparent, partly as a reaction against the excesses of the rococo and partly as a response to the discoveries about the antique world being unearthed at Pompeii and Herculaneum. But the linear austerities of the neoclassic style did not accommodate themselves as readily to the flowing lines of

the oriental porcelain as had the curves and scrolls of the rococo style. There were other factors, too, causing the taste for Far Eastern porcelain to wane. At just this moment strong economic pressures were brought to bear on the *marchands-mercier* to patronize the native *porcelaine de France* of Sèvres rather than use imported wares. Significantly, just at this period the Sèvres factory began to produce monochrome wares of an oriental character. These pieces were never painted with the interlaced L's of the factory's mark and have on occasion been taken for real Chinese porcelain.

The change of taste, of course, came slowly. Oriental porcelain with mounts in the rococo style was available in Paris right down to the Revolution. Nevertheless, the taste was declining, and the upheavals of the Revolution almost extinguished it. A few pieces with mounts in the Napoleonic style are known, but they are rare and not very attractive. For all practical purposes the taste was eliminated by the Revolution, with its strong reaction against the art of the ancien régime. It was not until well past the middle of the nineteenth century that collectors—other than a few eccentrics, such as the marquis of Hertford and Robert Earl of Pembroke in England or the duchesse de Montebello and the duc de Morny in France—paid any attention to such frivolous things, as they were then thought to be. But with the reawakening of the taste for eighteenth-century French art in the 1860s, mounted oriental porcelain came into its own once more. By the 1880s the demands of collectors had driven prices to such heights that forgeries began to appear. These counterfeits are often highly deceptive,[19] and several important museums in both Europe and the United States have examples on display as genuine eighteenth-century work.

FRANCIS WATSON

19.
At the Leybourne Popham Sale in 1882 a single mounted vase of celadon porcelain fetched what was at that time a record auction price of 2415 British pounds. There is good reason to believe the mounts were reproductions made only a few years earlier.

PLATES

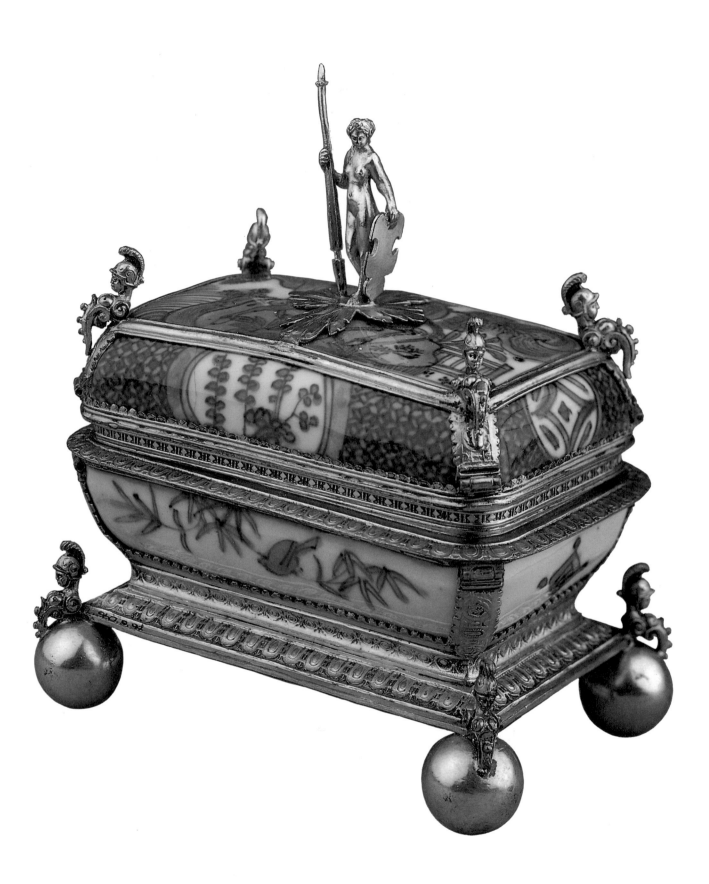

Blue-and-White Lidded Sweetmeat Box
Chinese porcelain with English silver-gilt
mounts. Lee Collection, courtesy of the
Massey Foundation and the Royal Ontario
Museum, Toronto (cat. no. 1).

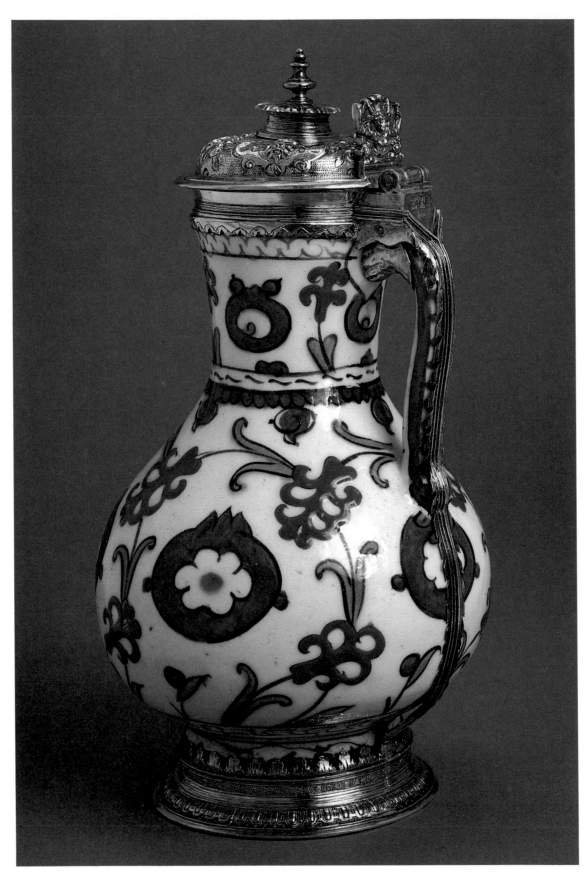

Tankard
Turkish porcelain with English silver-gilt
mounts. Syndics of the Fitzwilliam Museum,
Cambridge, England (cat. no. 5).

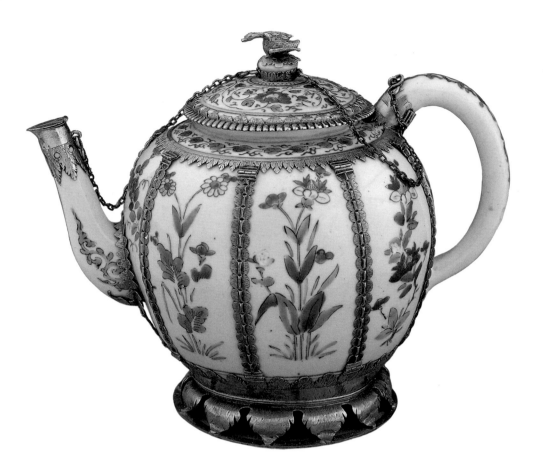

Teapot
Japanese porcelain with Dutch or French silver
mounts. Lee Collection, courtesy of the
Massey Foundation and the Royal Ontario
Museum, Toronto (cat. no. 11).

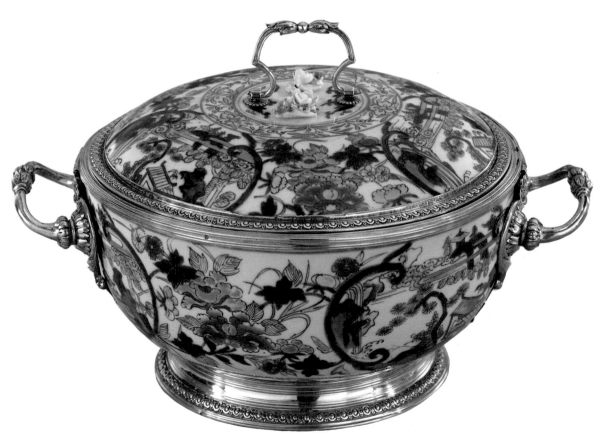

Lidded Bowl with Silver Mounts
Japanese porcelain with French silver mounts.
The Toledo Museum of Art, gift of Florence
Scott Libbey (cat. no. 14).

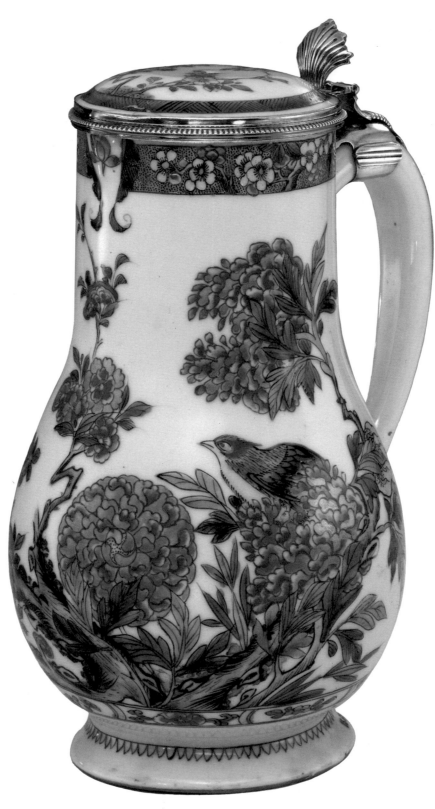

Lidded Jug
Chinese porcelain with French silver mounts.
The Metropolitan Museum of Art, New York
City (cat. no. 15).

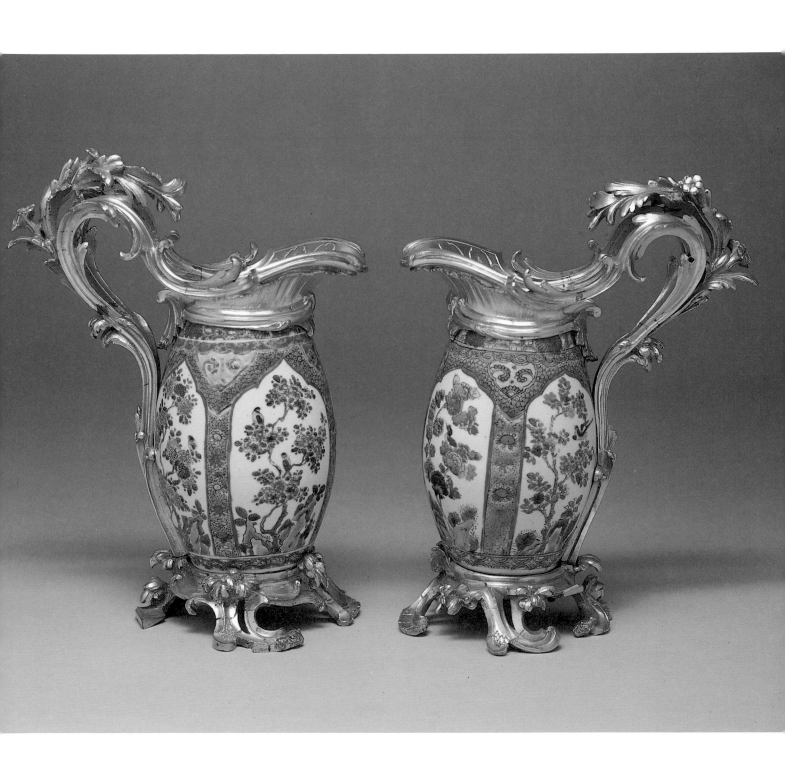

Pair of Vases Mounted as Ewers
Chinese porcelain with French gilt-bronze
mounts. The Fine Arts Museums of San
Francisco, Collis P. Huntington Memorial
Collection (cat. no. 21).

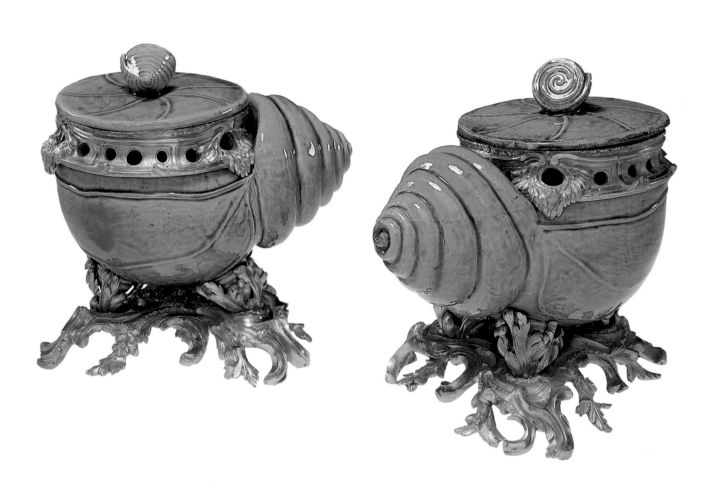

Pair of Turquoise Blue Shells
Chinese porcelain with French gilt-bronze
mounts. The Walters Art Gallery, Baltimore
(cat. no. 30).

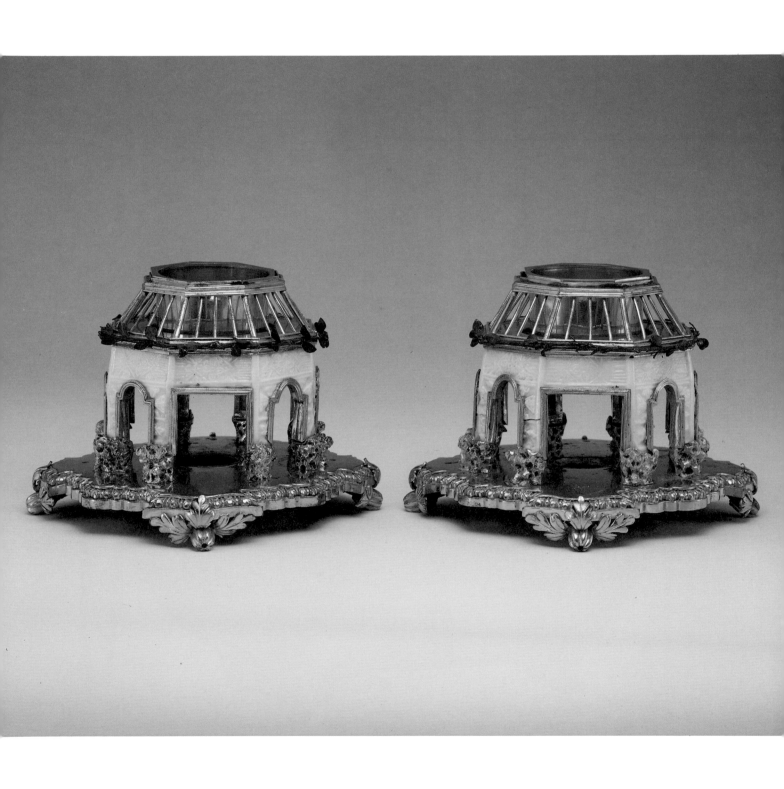

Pair of Perfume Burners
Chinese porcelain with French gilt-bronze
mounts. The Metropolitan Museum of Art,
New York City (cat. no. 31).

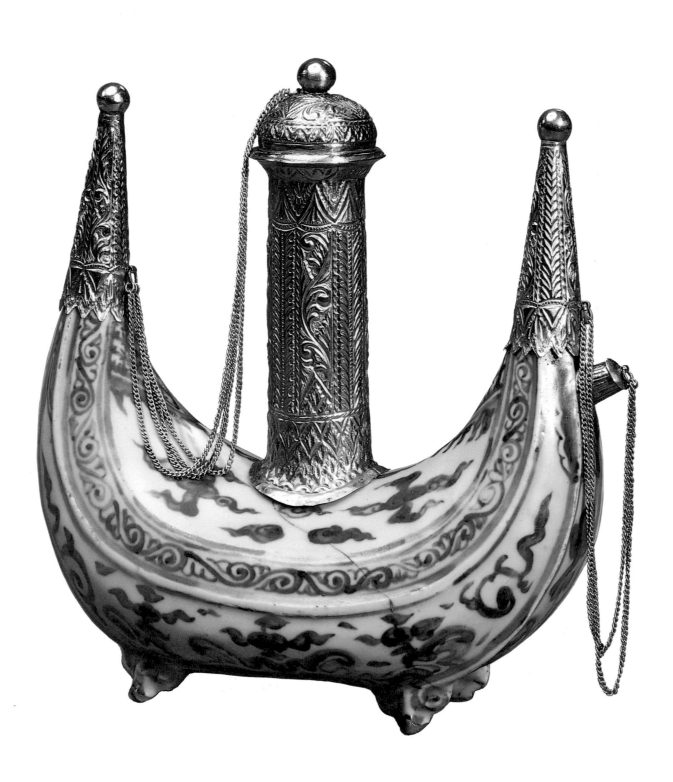

Boat-Shaped Porcelain Drinking Vessel
Chinese porcelain with Southeast Asian silver
mounts. The Ashmolean Museum, Oxford,
England (cat. no. 42).

CATALOGUE

Overall dimensions are given in inches (and centimeters), with height preceding diameter; the third dimension for some works is the width, which includes handles.

Entries are arranged in approximately the chronological order of the mounts, not of the porcelain.

Blue-and-White Lidded Sweetmeat Box

Porcelain: Chinese, Ming dynasty, 1573–1619
Mounts: English, silver-gilt, c. 1570
$5\frac{3}{4} \times 3\frac{1}{4} \times 5$ ($14.7 \times 8.2 \times 12.7$)
Lee Collection, courtesy of the Massey Foundation
and the Royal Ontario Museum, Toronto, Canada (L960.9.94)

The rectangular lidded box of Chinese porcelain of the Wanli period is decorated in underglaze blue and richly mounted with English silver-gilt dating from 1570.

The box, whose interior has two compartments, is painted around the sloping sides with leaf motifs and birds and on the lid in a diaper pattern with foliate sprays in circular reserves at the center of each side. The lid is surmounted at the center by a finial in the form of a nude female figure of silver-gilt holding a lance and a shield, and at each corner by the helmeted head of a Roman warrior above a scroll that joins the top to the rim of the lid by a hinged mount. The lid is hinged along one side and fits into the flanged mount running around the rim of the box. The mount is linked at each corner in three stages to the elaborately pierced and serrated silver-gilt molding, which clasps the underside of the box. The whole is elevated on large ball feet, one at each corner, which are surmounted by warrior heads similar to those above. The silver is unmarked but was certainly made in London.

Compare cat. nos. 2, 4, and 5, all mounted with English silver-gilt dating from the last years of the sixteenth century. Their mounts are all much simpler than those of the Lee box, to which some later additions, specifically the large ball feet, may have been made.

Formerly in the collection of Viscount Lee of Fareham and bequeathed by him to the Massey Foundation, which loaned it to the Royal Ontario Museum.

LITERATURE: Illustrated, Lunsingh Scheurleer 1980, fig. 26 (see Bibliography for complete citation).

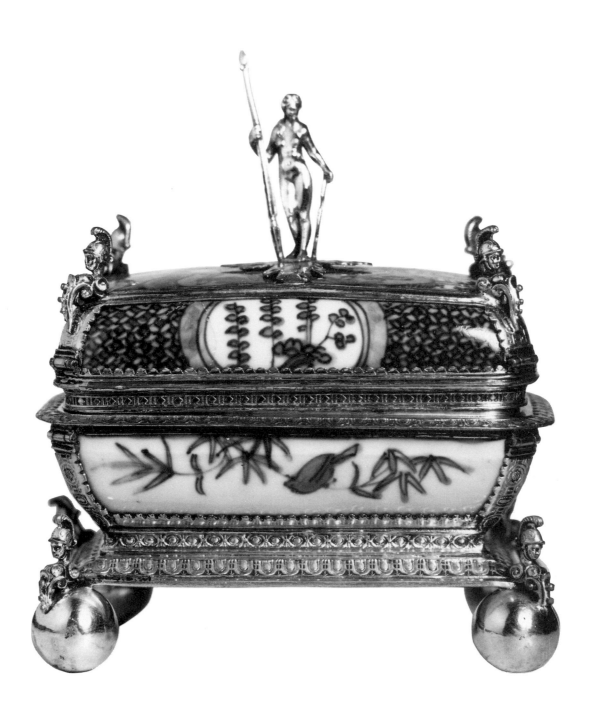

Blue-and-White Ewer

Porcelain: Chinese, Ming dynasty, 1573–1619
Mounts: English, silver, c. 1575–1600
8¹¹⁄₁₆ × 7½ (22 × 19.1); diameter of base: 3⅞ (9.8)
Museum of Fine Arts, Boston,
Theodora Wilbour Fund in Memory of Charlotte Beebe Wilbour (55.471)

This Chinese porcelain *kendi* of a type made for the Persian market dates from the Wanli period and is somewhat coarsely painted on the globular body with flowers, leaves, and a bird and on the tall flaring neck with vertical palm leaves alternating with stems.

To convert it into an ewer or wine pourer of European character, it was mounted with English silver, unmarked but dating from 1575–1600. The mounts take the form of a domed repoussé lid with a finial, a thumb piece in the form of a mermaid, and a scrolled handle that is attached at its lower end to a chased and scalloped silver collar below the neck. Three equally spaced silver straps, hinged and with scalloped edges, link the collar to the flanged foot rim, which is embossed with a diaper pattern. The bulbous mouth of the *kendi* has been fitted with a short, tapering, engraved silver spout with a mouthpiece in the form of a grotesque animal head.

A similar porcelain *kendi* with slightly richer English silver-gilt mounts, probably by the same goldsmith, was also formerly in the hands of the Parisian dealer Nicolas Landau (illustrated, Lunsingh Scheurleer 1980, fig. 32).

Compare cat. no. 6, which is of a similar character, and its accompanying commentary.

From the collection of Nicolas Landau in Paris. Acquired in 1955 for the Museum of Fine Arts, Boston.

EXHIBITIONS: New York, China Institute in America, 1980–1981, *Chinese Porcelains in European Mounts*, no. 27 (illustrated).

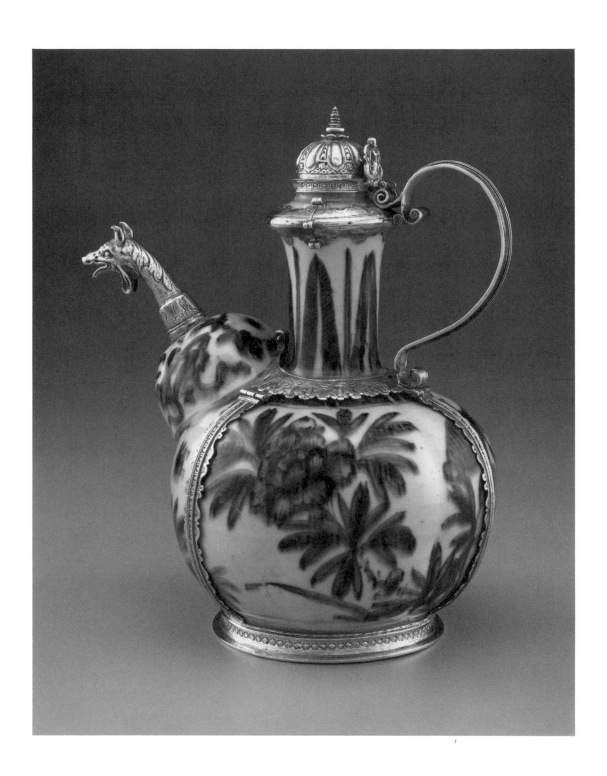

3 *Chalice*

Porcelain: Chinese, Ming dynasty, 1573–1616
Mounts: South German, silver-gilt, c. 1583
6½ × 4¾ (16.5 × 12)
Trustees of the Victoria & Albert Museum, London (M16.1970)

One of two similar chalices made from two bowls of Chinese porcelain of the Wanli period that are the same size but are decorated differently. Each is mounted on a tall stem of silver-gilt with an identical design. The companion to the Victoria & Albert chalice is engraved with the date 1583, presumably the date when they were made. It was sold at Sotheby's, London, 5 December 1970. The two are illustrated side by side in Lunsingh Scheurleer 1980, fig. 73.

The bowl of the Victoria & Albert chalice is decorated on the exterior in the *kinrande* style with an all-over design of foliate scrolls springing from a large leaf back and front in gold over an iron-red glazed ground; the interior has a repeating pattern of fleurons and the like in underglaze blue.

A simple circular platform with molded borders clasps the foot of the bowl. The platform is supported on a tall stem with a vase-shaped knop midway that is embossed with lions' masks and grotesque human heads, which are linked by swags of drapery, on a ground of clustered fruits. The stem rests on a wide molded foot, engraved around the upper part with floral motifs and scrolls and around the lower member with a flowing ribbon between pendant foliate motifs.

LITERATURE: Illustrated, Lunsingh Scheurleer 1980, fig. 74.

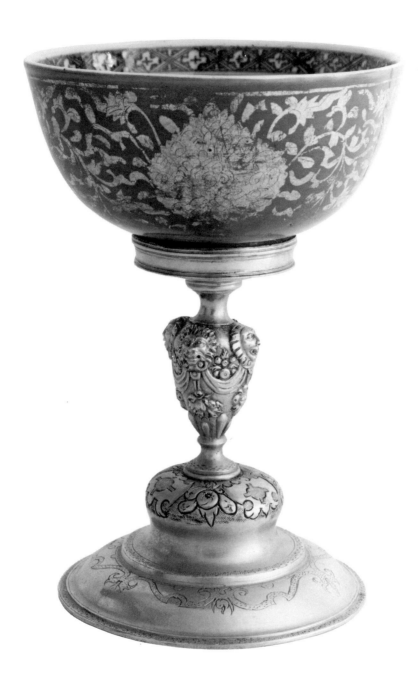

4 *Mounted Dish*

Porcelain: Chinese, Ming dynasty, 1573–1619
Mounts: English, silver-gilt, c. 1585
4 × 14⅜ (10.1 × 36.5)
The Metropolitan Museum of Art, New York City, Rogers Fund, 1944 (44.14.1)

This circular dish of Chinese porcelain of the Wanli period has high flaring sides and is painted in underglaze blue with groups of fruit and floral sprays on the exterior. In the interior, the bottom is painted with a circular scene of mountains and a river with a pleasure boat, a pagoda, and various figures below a border of lotus flowers and seated herons that runs around the rim. It is of the type sometimes referred to as *kraakporselein*, probably because it was carried to Europe in Portuguese ships called "carracks."

A double molding of silver-gilt stamped with repeating ovoli clasps the rim. The base of the dish is raised on a high foot of silver-gilt with egg-and-dart and interlacing strapwork moldings that have cutout foliations at the top. Four equally spaced, shaped straps of silver-gilt link the foot to the mount around the rim. The foot is stamped with the mark of an unidentified English silversmith, three trefoils voided with a shaped shield. Beneath the foot a crescent is scratched.

The dish is one of a group of blue-and-white porcelain with English silver-gilt mounts of c. 1585–1600 made for William Cecil, Lord Burghleigh (1520–1598), Queen Elizabeth I's treasurer. They are among the earliest pieces of oriental porcelain with English mounts to survive. They remained in the possession of Cecil's descendants, the marquises of Exeter, at Burghleigh House in Northamptonshire, until sold by Christie's, London, 7–8 June

1888. They were bought at auction by the well-known London dealers Agnew and Sons and subsequently sold to J. Pierpont Morgan (New York and London), who loaned them to The Metropolitan Museum of Art in 1913. Later, in 1944, the museum acquired the dish, a mounted bottle, and two mounted bowls. Other mounted porcelain objects of the same type remain at Burghleigh House.[1]

The London silversmith is unidentified, but the Victoria & Albert Museum in London has a porcelain jug mounted in 1585–1586 by the same silversmith.[2]

A very similar mounted dish appears in a painting by William Kalf formerly in the collection of Baronne Bentinck.[3]

EXHIBITIONS: London, Burlington Fine Arts Club, *Blue and White Oriental Porcelain*, 1895, catalogue pp. xv–xvi (with other Burghleigh pieces, nos. 34–37, loaned by William Agnew), and *Early Chinese Pottery and Porcelain*, 1909–1910, New York, Metropolitan Museum of Art, Department of Chinese Art exhibition, 1940; Chicago, David and Alfred Smart Gallery, 1985, *Chinese Porcelain and Its Impact on the Western World*, cat. no. 48.

LITERATURE: C. Louise Avery, "Chinese Porcelain in English Mounts," *Metropolitan Museum of Art Bulletin* 2 (May 1944): 266–272 (with other Burghleigh mounted porcelain in the Metropolitan Museum); Edward Wenham, "Porcelain with Silver-Gilt Mounts," *Argentor* 3 (1948): 103–113; Hackenbroch 1955 (see Bibliography for complete citation); illustrated, Lunsingh Scheurleer 1980, fig. 10.

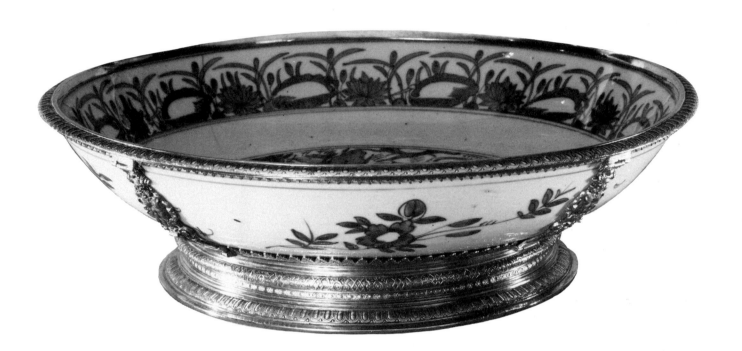

5 *Tankard*

Pottery: Turkish, second half of the sixteenth century
Mounts: English silver-gilt, 1592, by a maker using the initials, IH
10 × 5½ (25.4 × 14.1)
Syndics of the Fitzwilliam Museum, Cambridge, England (M.16-1948)

This jug, which has a bulbous body and a short narrow neck, is painted in underglaze Rhodian colors—blue, green, and sealing wax or tomato red—with conventional floral trails and other typical Isnik motifs. It is modeled with a simple ceramic handle that springs from the upper part of the body at one side and joins the lip.

The vase has been mounted with a hinged lid and a foot of silver-gilt to convert it into a drinking vessel. A simple ribbed molding embossed with foliations around the lower edge clasps the lip. The slightly domed lid is embossed with floral and leaf motifs and surmounted by a bobbin-shaped finial. The mount bears the London hallmark for 1592 and the mark of an unidentified silversmith using the initials, IH.

The lid is hinged to the handle, which has a thumb piece of foliate form. The foot of the jug is clasped by cut leaves above a stepped and molded base with a border of egg-and-dart decoration around the lower edge. A long ribbed molding of silver-gilt clasps the outer edge of the handle to link the base to the lid.

Three jugs or tankards of Isnik ware with silver-gilt mounts by the London silversmith "IH" are known: the Fitzwilliam tankard exhibited here, formerly in the Dysart collection; one formerly in the Swaythling collection dated 1586–1587; and one in the Franks collection in the British Museum dated 1597–1598.[1] A fourth in the Victoria & Albert Museum is undated.

Although Near Eastern ceramic pieces like this tankard, with European metal mounts of fine quality, are much rarer than Chinese porcelain so treated, the evidence above shows that such examples were far from unknown in the Elizabethan period. Several contemporary references to unmounted Turkish or Isnik ware show that it was to be seen in London during this period.[2] Evidence that Isnik ware was mounted elsewhere in Europe also exists, for the silver-gilt mounts for a tankard survive in the museum at Halle in Germany with an inscription referring to Nicea (Isnik) where the pottery was made.

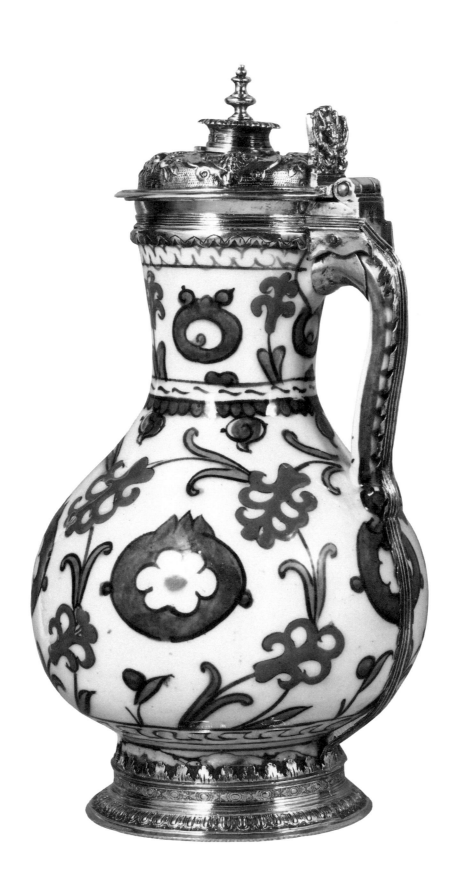

Blue-and-White Ewer Mounted as a Wine Taster

Porcelain: Chinese, Ming dynasty, 1573–1619
Mounts: English, silver, c. 1610
10^{15}/$_{16}$ × 6$\frac{3}{8}$ × 9$\frac{7}{8}$ (27.8 × 16.2 × 25.1)
The Art Institute of Chicago, gift of Mrs. Medard W. Welch (1966.133)

This *kendi* of Chinese porcelain of the Wanli period is painted in underglaze blue with panels of flowers on the bulbous lower section and with flowering plum branches on the trumpet-shaped neck. It was converted into a European-style ewer by the addition of mounts of English silver dating from c. 1610 and struck three times with the unidentified mark, EI within a shield.

The mounts consist principally of a splayed reeded foot, with an upper border of engraved serrated leaves. Linked to the base are four straps around the body of the ewer: three join a mount that encircles the base of the neck; the fourth joins the base of the high tapering spout that terminates in a mouth in the form of an eagle's head. On the side opposite the spout is a plain scrolling handle of silver joined to the domed silver lid with a baluster-shaped finial opened by a plain thumb piece.

Such *kendi*, originally made for export to the Middle East as hookahs, seem to have reached Europe in large numbers in the late sixteenth and early seventeenth centuries. The earliest recorded mounted *kendi*, in a private collection in 1920 (present whereabouts unknown), bears the London hallmark for 1584. Several with similar English mounts, to adapt them as ewers of European type, are known. A slightly smaller ewer in the Victoria & Albert Museum in London has silver mounts with the unidentified maker's mark, RP. A third, again smaller, was also in the George Spencer-Churchill Collection (see below). Closest of all is a *kendi* of very similar design with almost exactly the same mounts, probably by the same goldsmith, that was sold at Christie's, New York, 26 May 1965, lot 45.[1]

Formerly in the collection of Edward Spencer-Churchill, Northwick Park, Blockley, England. Sold, Christie's, New York, 26 May 1965, lot 144 (illustrated).

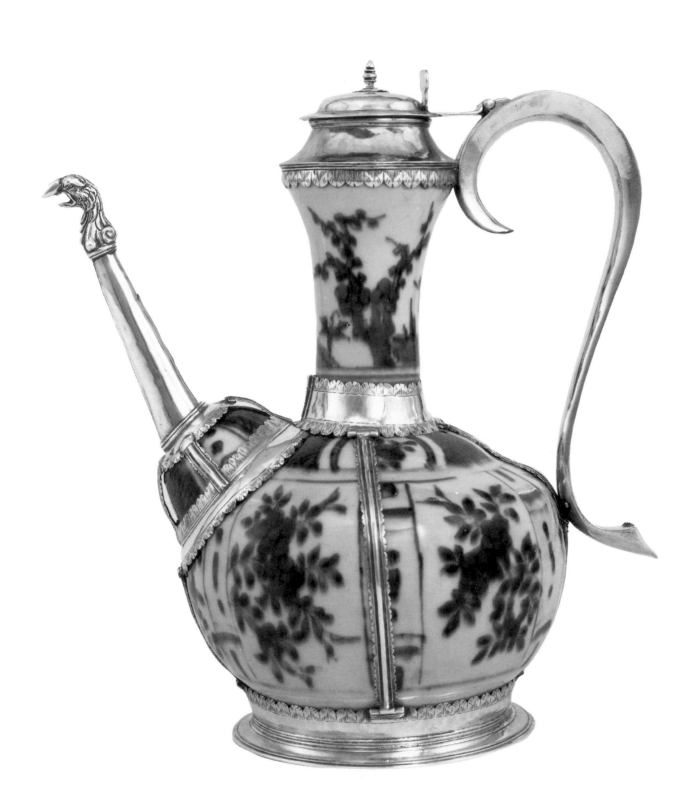

7 *Mounted Porcelain Tazza*

Porcelain: South Chinese Swatow ware, late sixteenth century
Mounts: English, silver-gilt, c. 1650
$5\frac{3}{4} \times 14$ (14.7 × 35.6)
Private collection, through the Royal Ontario Museum, Toronto, Canada (L960.9.107)

The shallow dish of Swatow porcelain of the late sixteenth century is mounted with English silver-gilt around the rim and the foot. The mounts are of the seventeenth century and are struck with the unidentified maker's mark, I.V.

The bowl, probably of South Chinese origin, is painted in underglaze grayish blue on white with floral and leaf motifs that have "slipped" in the firing. A silver-gilt molding clasps the flaring rim below which depend alternating groups of large and small lappets of foliated outline. The bowl sits on a high base pierced with inverted acanthus leaves above which a molding, resembling that below but inverted and shallower, clasps the foot.

Compare the similar but earlier dish with English silver-gilt mounts, cat. no. 4.

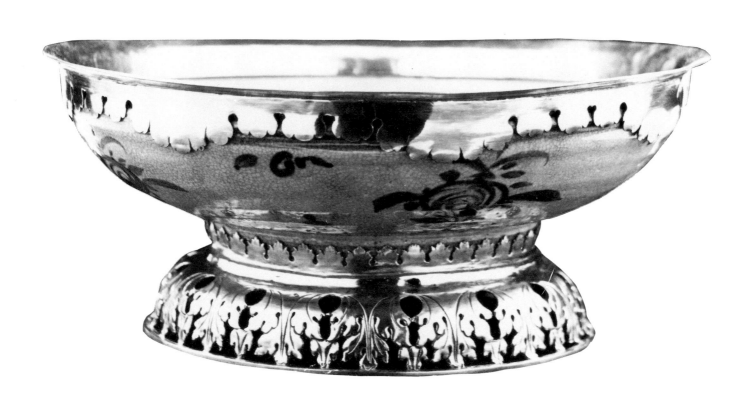

Lidded Wine Jug or Flagon

Porcelain: Japanese, Arita, c. 1660
Mounts: Dutch, silver-gilt, 1666, made by Barent van Leewven (d. 1682)
9½ × 4½ × 5 (24 × 11.5 × 12.7)
The Cleveland Museum of Art,
gift of the Lucile and Robert H. Gries Charity Fund (70.47)

The flagon, of white Japanese porcelain painted in underglaze blue, is of European form and made for export at Arita around 1660. The ovoid body has a splayed foot and a tall neck indented around the joint with the body. A simple curving handle joins the body to the lip.

The neck is painted with a band of peonies and leaves, the foot with a band of arabesques, and the center of the body in front with a coat of arms, probably those of a member of the Geebrinck family who played an important role in Amsterdam in the seventeenth century.

The pinched lip is encircled by a band of silver embossed with leaf motifs to which a plain domed lid is hinged. The lid can be raised by a thumb piece in the form of two snakes that are attached to the upper part of the handle by a hinged clasp. A wide silver molding with cutout leaves along its upper edge surrounds the bottom of the neck, and a plain molded band of silver clasps the upper part of the foot. The lid is struck with several marks: the mark of Amsterdam; the date-letter for 1666; and the mark of the silversmith Barent van Leewven, among others.

Barent van Leewven specialized in small works of silver, such as toys. He became a freeman in 1637 and died in 1682. One other silver lid by van Leewven for a jug of Japanese porcelain has survived and is also dated 1666. It was formerly in the Dreesman collection.

The form derives from German stoneware jugs, which were probably sent out to Japan by the Dutch as models. A number of other examples of this type of jug of Arita porcelain are known, notably in the museum at Groningen in Holland.[1]

LITERATURE: Illustrated, Lunsingh Scheurleer 1980, fig. 400 a-b.

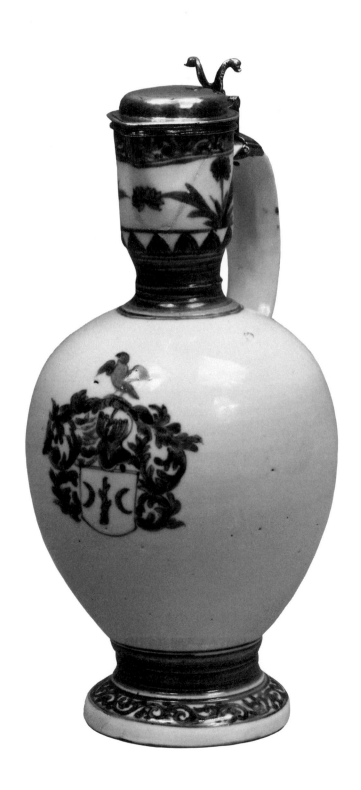

Lidded Bowl with Mounts

Porcelain: Japanese, Arita, c. 1650
Mounts: English (?), gilt metal, c. 1670,
attributed to Wolfgang Howser (working in England from c. 1660 until after 1688)
13⁹/₁₆ × 10¹/₁₆ × 15 (34.5 × 25.5 × 38)
The J. Paul Getty Museum, Malibu, California (85.DI.178.1)

One of a pair of bowls of Japanese Arita porcelain of the mid-seventeenth century with mounts of gilded metal, probably of English origin, and perhaps the work of Wolfgang Howser.

Both bowls and their lids are painted in underglaze blue with landscapes, trees, flowers, and buildings. At the center of the lid and around the base is a repeating band of lappets and semicircles, also enameled. The low domed lid has a flaring porcelain knob that is clasped by a finial of gilt metal oak leaves with acorns on one side. The lower edge of the lid is framed in a flanged and gadrooned molding that fits into the bowl whose rim is encircled by a pierced and foliated band of metal. A high gadrooned base embossed with foliate scrolls supports the foot of the bowl. The base is linked to the rim at left and right by a wide metal band embossed with shells, scrolls, foliations, and fruit and is attached top and bottom by a pinned hinge.

Each band supports a scrolling handle up which a hound climbs, its head turned sharply sideways.

Japanese porcelain began to arrive in Europe in considerable quantity only in 1660, so the Getty bowl must be among the earliest to have been mounted in the West.

The basis for the attribution of the mounts to Wolfgang Howser, or a close follower, is the resemblance of the handles, and indeed the foot and rim mounts, to those of a Chinese blue-and-white porcelain vase mounted in silver-gilt as a tankard that is now in the Victoria & Albert Museum in London.[1] These mounts bear the mark, WH above a cherub, for Wolfgang Howser or Houser.

Little is known of this goldsmith. He came from a family of goldsmiths from Zürich and was apprenticed to his father Hans Jacob Howser II, completing his training in 1652. He seems to have been working in England 1660–1661 when he supplied a gilt and embossed communion flagon

to the chapel of the bishops of Durham at Auckland Palace. He likewise furnished altar dishes for St. George's Chapel at Windsor Castle and the Chapel Royal at Whitehall Palace. He was granted his mark, WH above a cherub, after 1664 and was joined by his nephew Hans Heinrich Howser (who could have mounted the Getty bowl) in 1681. Wolfgang Howser was last mentioned in 1688.

Similar hounds of silver-gilt form the handles of a richly mounted lidded cup of red glass dated c. 1660 that belongs to the National Trust at Anglesey Abbey in Cambridgeshire, but these handles bear the mark, WH with a scallop.

Formerly in the collections of Joseph Downs, New York, and William Heere, New York. Sold, Christie's, New York, 29 October 1983, lot 32; purchased in Paris in 1985 by The J. Paul Getty Museum.

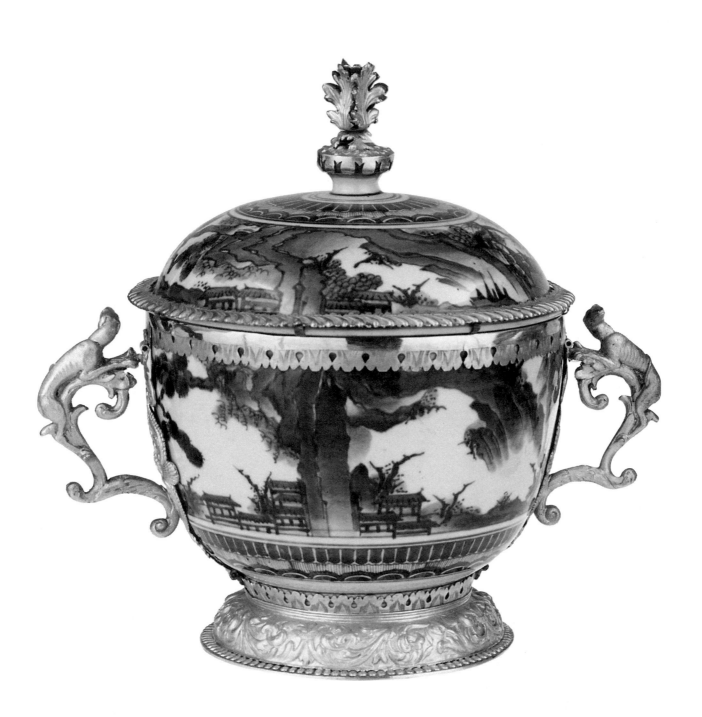

Wine Pourer

Porcelain: Japanese, Arita, late sixteenth century
Mounts: Dutch, silver, 1685, made by Daniel Bouman (1644–1692)
$9\frac{1}{4} \times 4\frac{3}{4} \times 5\frac{1}{2}$ (23.4 × 12 × 14)
Dr. and Mrs. Walter Liedtke, New York City

The body of this wine pourer is in the form of an ewer of Japanese Arita porcelain of the late sixteenth century with a mouth and thumb piece of Dutch silver of 1685. The porcelain pouring vessel, which has a globular body, tall flaring neck, and simple applied porcelain handle, is painted somewhat crudely with landscapes and trees in three oval reserves on the sides and with leaf trails on the neck, all in underglaze blue.

The silver mounts comprise a molded rim with a pointed lip around the mouth and a shell-shaped thumb piece that is hinged to a mount in the form of a serrated leaf and attached to the top of the handle by hinges at each side. The plain cover or lid is slightly domed. The silver bears the following marks: the Amsterdam mark; the Netherlands mark; a Y, the date-letter for 1685; and three trefoils within a heart-shaped shield, the mark of the Dutch silversmith Daniel Bouman.

A similar jug with very similar Dutch silver mounts and a Dutch coin of 1688 inset in its lid is in the Franz Hals Museum in Haarlem.[1]

Unlike the ewers made in France by mounting oriental porcelain, the Dutch mounted flagons had a definite functional purpose as decanters for pouring wine at table. This ewer, which is of European form, was probably made after designs sent from Holland to the Far East. Large numbers of them were made there for the Dutch market and numerous examples are illustrated in Lunsingh Scheurleer 1980. They also appear in Dutch paintings of the seventeenth century.

The Dutch were the principal importers of Japanese porcelain into Europe, and for a long period in the seventeenth and eighteenth centuries they had the exclusive right to trade with Japan. The Japanese porcelain mounted in France was usually bought on the Amsterdam market for that purpose by Parisian *marchands-mercier*. The first large consignment of Japanese porcelain to reach the European market arrived at the port of Amsterdam only in 1660, long after Chinese porcelain had been coming there regularly.

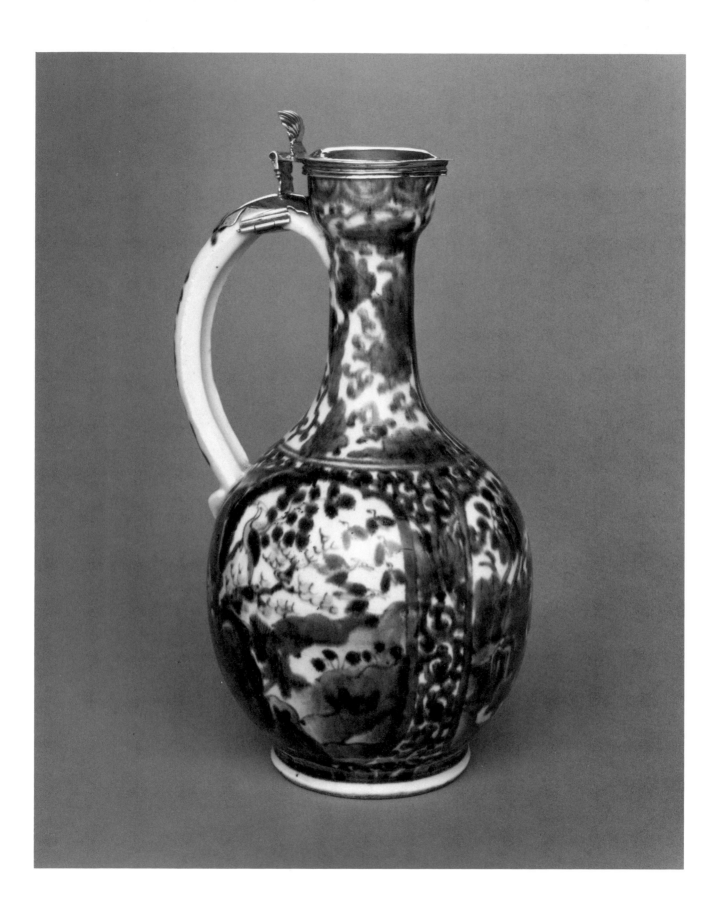

Teapot

Porcelain: Japanese, Arita, c. 1675–1685
Mounts: Dutch or French (?), silver-gilt, c. 1685
6 × 14 (15.2 × 35.6)
Lee Collection, courtesy of the Massey Foundation
and the Royal Ontario Museum, Toronto, Canada (L960.9.96 a–b)

This teapot of Japanese *kakiemon* porcelain of the late seventeenth century has a globular body, attached curving handle, and short vertical spout. It is mounted around the body, foot, lid, and spout with silver-gilt of c. 1685.

The sides of the bulbous body are enameled in *kakiemon* colors with eight vertical sprays of various flowers. A band of scrolling flowers and leaves surrounds the shallow domed lid, which has a flattened porcelain knob. The body of the teapot is divided into eight panels by silver-gilt straps with serrated and foliate borders on each side; each panel encloses a single vertical spray of flowers. A pinned hinge attaches the straps at the bottom to the foot mount and at the top to a narrow band of pendant cutout leaves that surrounds the shoulders of the teapot. A band of gadrooned and foliate silver-gilt clasps the rim of the lid. A silver-gilt finial of floral form surmounts the knob. The mouth of the spout is enclosed with a silver-gilt band of pendant cutout leaves into which the plain silver-gilt stopper is inserted. Raised on a high base of engraved and inverted

acanthus leaves, the foot of the teapot is clasped by an engraved and foliate molding of silver-gilt. The mounts have generally been considered to be English, but there is some evidence, for example, the form of the finial, to suggest that they may be Dutch or possibly French. A similar teapot with *kakiemon* decoration and French silver mounts with Paris marks dated 1722–1727 was formerly in the collection of the Paris dealer Nicolas Landau.[1] It lacks the foot mount and the strapwork on the sides, but these are more characteristic of English than French silver.

Formerly in the collection of Viscount Lee of Fareham and bequeathed by him to the Massey Foundation, which has placed it on loan to the Royal Ontario Museum in Toronto.

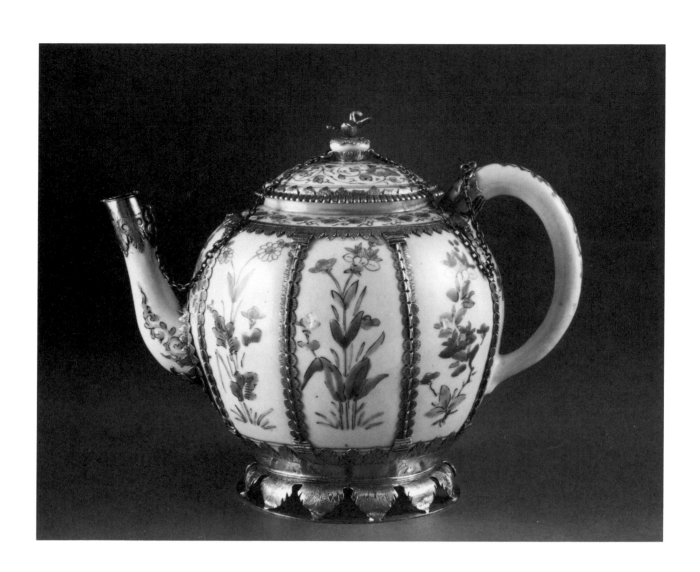

Teapot

Porcelain: Chinese, Qing dynasty, 1720–1725
Mounts: Provincial French (?), silver, early eighteenth century, repaired in 1780–1791
4 × 3 × 5⅛ (10.1 × 7.6 × 13)
Private collection, through the Royal Ontario Museum, Toronto, Canada (L986.5)

The octagonally shaped body, which tapers toward the foot, is painted on either side in underglaze blue with a single Chinese figure in a landscape or a sinuous spray of flowers. The domed and ribbed lid is also painted with flowers in underglaze blue and has a conically shaped porcelain knob.

The neck and foot are enclosed in plain octagonally shaped moldings engraved with festoons of drapery of a neoclassic character. These moldings must have been added later to strengthen the original piece, for the molding around the neck bears the mark of the city of Lyons for 1780–1791, a date much too late for the mounts of the lid and the handle.

The earlier mounts comprise a band of cut and engraved leaves around the base of the lid and three shaped bands of silver around the handle, one at each junction with the body and a third at the center. The lid is attached to the uppermost mount of the handle by a short chain that links it to a plain collar around the knob of the lid.

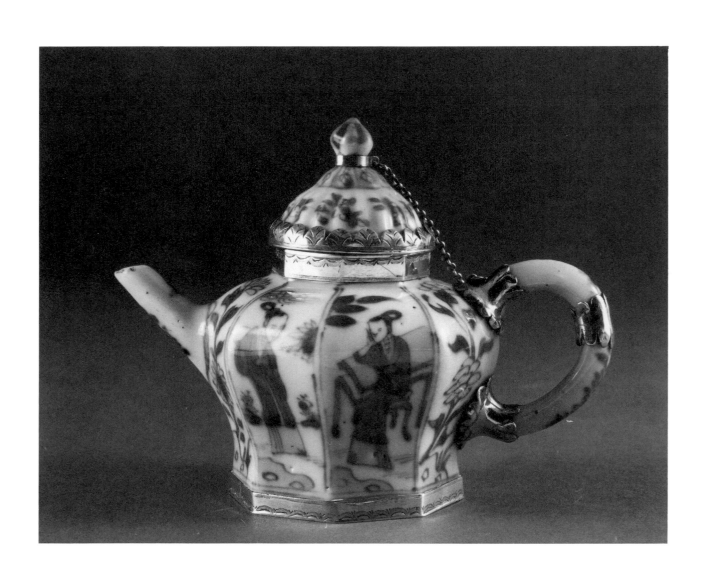

Lidded Bowl with Silver Mounts

Porcelain: Japanese, Imari, c. 1700
Mounts: French, silver, c. 1720
11 × 10^{13}⁄$_{16}$ × 13^3⁄$_8$ (28 × 27.5 × 34)
The J. Paul Getty Museum, Malibu, California (79.DI.123)

This deep circular bowl of Japanese Imari porcelain of c. 1700 has a two-staged domed lid and is mounted around the foot, lip, and lid with French silver of c. 1720. It is also fitted with a silver handle at each side; a silver finial surmounts the lid.

The porcelain body is painted on the exterior with irregularly shaped overlapping panels of various flowers and trees in deep underglaze blue and overglaze iron red with gilding. The two-part lid is taken from two different objects of Imari porcelain. An inverted shallow dish painted with floral motifs in green and yellow enamel over underglaze blue forms the lower stage; a smaller domed lid from another vase, decorated partly in relief with flowers and foliage in the same range of colors, forms the upper stage.

The lip of the bowl is encircled by a gadrooned silver molding, flanked at each side by a handle linked to the foot by a pierced silver mount that is attached above and below by a pinned hinge. A simple gadrooned molding embellishes the foot. A deep band of silver chased with cartouches enclosing fleurons against a matted ground encircles the lower edge of the lid. At the joint between the two stages a gadrooned molding encircles the lid; the finial is in the form of a foliate cup heaped with berries.

The silver is unmarked, but by comparing it with an Imari bowl with silver mounts of the same design in the Bayerisches Nationalmuseum in Munich bearing the Paris hallmark for 1717–1722, it seems likely that the Getty bowl dates from c. 1720. Compare cat. no. 14 also of Imari porcelain with silver mounts of a closely similar date.

A pair of lidded bowls of Arita porcelain in the Residenzmuseum in Munich (PVG 394; PVG 395) have similar but simpler mounts of Parisian silver of c. 1710–1715. The mounts include a finial in the form of a foliate cup heaped with berries. But another lidded bowl of Japanese porcelain similarly mounted with silver of the same design, in the Musée des Arts Décoratifs in Paris (GR 426), is dated much later. It bears the mark of the Parisian goldsmith Pierre-François Roger who became *maître-orfèvre* (master goldsmith) only in 1781. He may only have repaired or restored earlier mounts.

Formerly in the collection of Mrs. Walter Burns (sister of J. Pierpont Morgan) and her descendant General Sir Gordon Burns. Purchased at his sale at North Mymms Park, Hertfordshire, Christie's, 24–26 September 1979, lot 45 (illustrated) by The J. Paul Getty Museum.

EXHIBITIONS: London, 25 Park Lane, 23 February–5 April 1933, *Three French Reigns*, cat. no. 226.

LITERATURE: Gillian Wilson, *The J. Paul Getty Museum Journal* 8 (1980): 8; Watson, Wilson, and Derham 1982, cat. no. 3 (see Bibliography for complete citation).

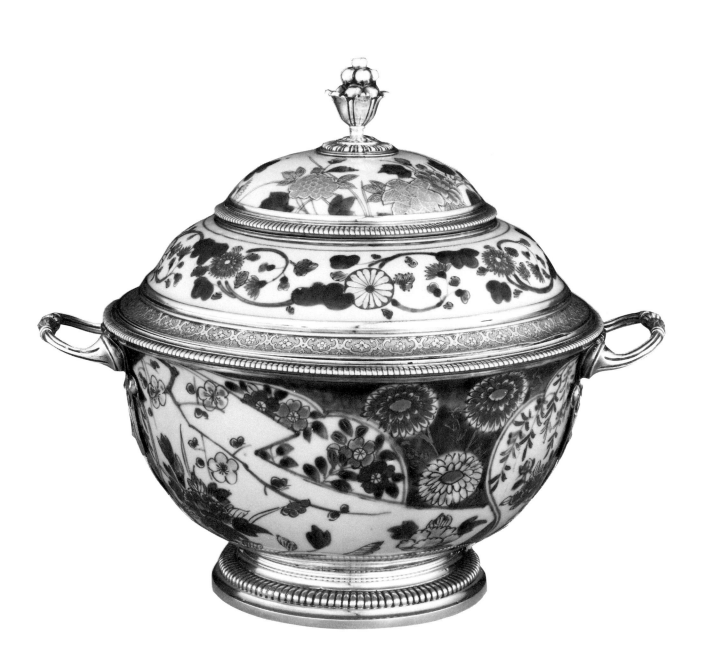

Lidded Bowl with Silver Mounts

Porcelain: Japanese, Imari, c. 1700–1725
Mounts: French, silver, c. 1722–1726
8¼ × 13⅜ (21 × 34)
The Toledo Museum of Art, gift of Florence Scott Libbey (73.49 a-b)

This deep circular bowl of Japanese Imari porcelain of the first quarter of the eighteenth century has a shallow domed lid and is mounted around the foot, the lip, and the lower edge of the lid with French silver dating from 1722–1726.

The porcelain is painted with tree peonies and other flowers alternating with landscapes framed within scrolled reserves edged in underglaze blue. Two flowers on the lid are in relief.

The foot is clasped in a deep molding of silver with alternating ovoli and small circles within an interlacing ribbon. A molding of similar design but shallower encircles the lower edge of the lid and fits into the flanged silver lip of the bowl. The lid is surmounted by a shaped, hinged handle with a foliate knop at the center. The bowl is clasped at each side by a decorative pierced mount that links the foot to the rim and is joined to the moldings, top and bottom, by a hinge. Above the center of each mount is the mask of satyr crowned with vine leaves. A prominent, fixed silver handle springs from two foliate bosses above each pierced mount. Each handle has a double knop chased with leaves at its center.

The mounts are struck with the Paris discharge mark for 1717–1722.

Compare cat. no. 13 for a bowl of closely similar form and date.

LITERATURE: Illustrated, Lunsingh Scheurleer 1980, fig. 437 a–b.

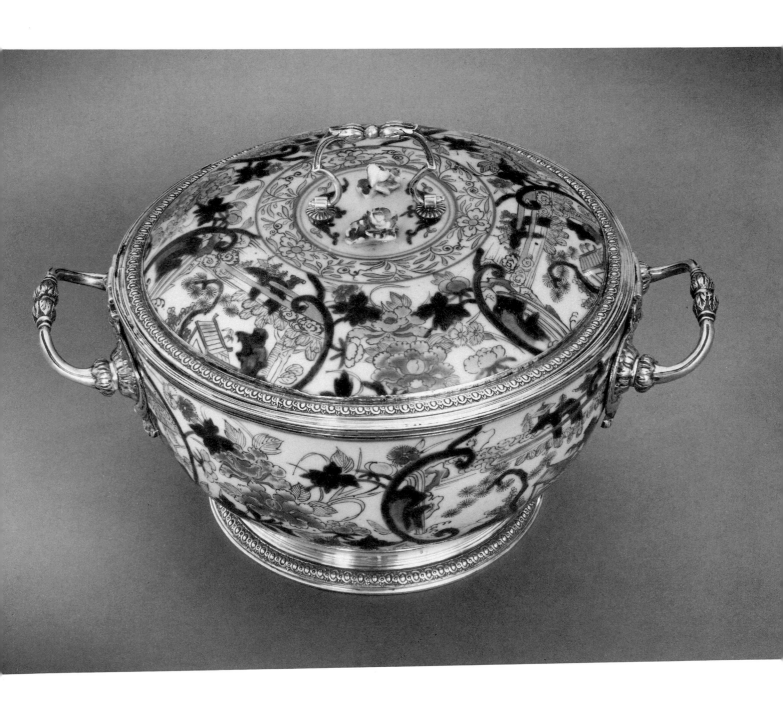

Lidded Jug

Porcelain: Chinese, Qing dynasty, 1662–1722
Mounts: French, silver, 1727–1732
8¾ × 3½ × 6 (22.2 × 8.9 × 15.2)
The Metropolitan Museum of Art, New York, Rogers Fund (25.60.3)

This jug of Chinese porcelain of the Kangxi period has a bulbous body, tapering slightly toward the mouth, and a simple curving handle and lid. The body is enamelled in *famille verte* colors with birds and insects amid flowering branches. It is fitted with gadrooned silver mounts around the lid and the foot and with a hinge and a thumb piece in the form of a shell attached to the upper part of the handle.

The model is known both in French earthenware (that is, in Rouen faïence) and in Dutch. In Holland such jugs are referred to as beer pots. These pieces were usually ordered for Dutch use and are first known to have been supplied to the Dutch trade in 1661, according to Volker 1952 (see Bibliography for complete citation).

The silver mounts bear the Paris date-letter for 1727–1732. A similar jug with gilt-bronze mounts, closely resembling those of the Metropolitan's jug, is in the Victoria & Albert Museum in London.[1]

This jug is an unusual example of a useful ware being mounted in France. Such mountings were a more common practice in Holland. In both countries the mounting of enameled wares of *famille rose* or *famille verte* is also rarer at this period than the mounting of blue-and-white or monochrome porcelain.

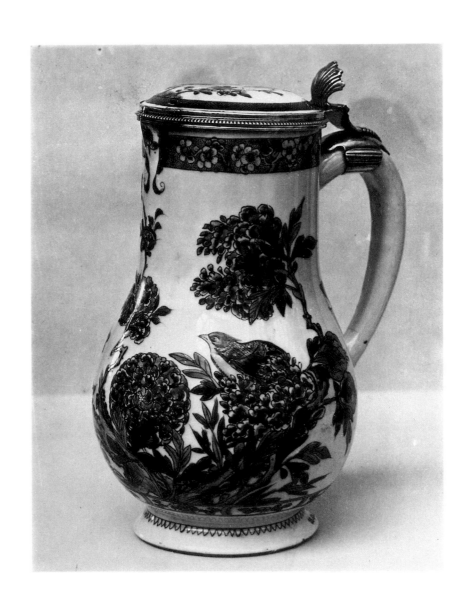

Potpourri Vase in the Form of a Shell

Porcelain: Japanese, Arita, mid-eighteenth century
Mounts: French, gilt bronze, 1730–1740
9 1/16 × 8 5/8 × 6 1/2 (23 × 22 × 16.5)
Private collection

The body of the univalve shell is of white Japanese porcelain painted on the exterior in a mottled brownish ground, with coral, algae, and starfish in blue, green, and red. The heavy lip of the shell is somewhat crudely painted a bright tomato red. The circular lid, rising to a point at the center, is similarly painted. The whole rests on three porcelain feet in the form of small sea shells.

The piece is elaborately entwined with gilt bronze. The high base is in the form of algae, shells, rockwork, incrustations, waves, and pouring water. From this base springs a leaf spray (perhaps intended to simulate seaweed) that twines up the side of the shell to clasp the lid, which is encircled with gilt bronze around its lower edge. The lower edge, in turn, is raised by trails of algae and shells slightly above the main body of the shell to permit the aromas of the potpourri to emerge.

In the discussion of cat. no. 27, a number of examples of mounted porcelain shells are described from eighteenth-century French documents. Of these, the pair belonging to Jean de Julienne, which is listed in his posthumous sale catalogue in 1767,

perhaps comes closest to the example described in this entry, but without the dimensions of that pair, it is impossible to identify them with certainty. The description of the two shells in the Radix de Sainte-Fox sale of 1782 also comes very close to the appearance of the shell presently under discussion, but the discrepancy in size precludes identification with those shells also.

Formerly in the collections of Georges Wildenstein, Daniel Wildenstein, and Akram Ojjeh. Sold with the Akram Ojjeh collection, Sotheby Parke Bernet, Monaco, 25–26 June 1979, lot 66 (illustrated in color, p. 92).

LITERATURE: Illustrated, *Sotheby à Monaco, 10 Ans, 1975–1985* (Monaco, 1986), on the dust jacket and on an unnumbered page where the sale catalogue description is also repeated.

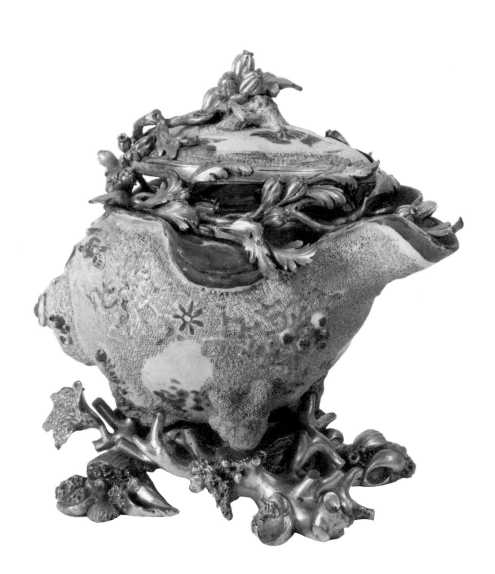

Decorative Group

Porcelain: Chinese, Qing dynasty, c. 1700–1745, with French porcelain flowers
Mounts: French, gilt bronze, c. 1745–1749
14 × 5 × 15 (35.6 × 12.8 × 38.1)
The Walters Art Gallery, Baltimore, Maryland (54.2261)

The figure and cup, both of *blanc de chine* (Fukien) porcelain of the first half of the eighteenth century, are mounted in an elaborately scrolled arbor of French gilt bronze dating from 1745–1749 and richly set with porcelain flowers.

The gilt-bronze scrolls forming the raised base of the group are struck three times with the crowned-C, a tax marking used during the brief period 1745–1749.

At the right, the white porcelain figure of Pu Tai Hosang, a Chinese apostle of the Buddha, sits on a high scrolled base of gilt bronze beneath a rustic archway of gilt-bronze boughs to which colored porcelain flowers are attached. At the left, also on a high scrolled base linked to the first, is a white porcelain libation cup filled with porcelain flowers attached to gilt-bronze stems. The cup rests on an openwork support of stems and porcelain flowers.

Pu Tai Hosang, his bag over his left arm, wears a *rocaille* headdress of gilt bronze and sits on rockwork of the same material. The rustic archway terminates above his head in a foliate finial. The lip of the cup is encircled by a narrow roped molding of gilt bronze, and porcelain flowers spring from the scrolling base at irregular intervals. The flowers here and on the arbor are of either Vincennes or Saint-Cloud porcelain.

M. Pierre Verlet has suggested that the cup and its supporting scrolls may be an addition, and certainly the gilt bronze is not struck with the crowned-C like the rest. If he is correct, his further suggestion, that the group may have then become a *brûle-parfum* (cassolette) in which perfumes in liquid form were dispersed by heating, is probably also correct.

Such fantastic compositions, combining Eastern and Western porcelain with gilt bronze for both decorative and functional purposes, were fashionable in Paris in the middle of the eighteenth century. Often, they furnished a base for a candlestick or a candelabrum. Compare cat. no. 28. A pair of candelabra sold by the *marchand-mercier* Lazare Duvaux to M. de Fontaine, *fermier-général*, on 13 March 1756 must have resembled the Walters group closely except for the color of the porcelain figure:

Une paire de girandoles à terrasse et branchages dorés d'or moulu sur des magots anciens bleu-céleste garnis de fleurs de Vincennes assorties, 264 l[ivres].[1]

Even closer was an object sold on 22 December 1751 to the duchesse de Rohan:

Deux magots d'ancienne porcelaine blanche sous des berceaux dorés avec lec terrasses aussi dorées d'or moulu, 300 l[ivres].[2]

Formerly in the collections of Arnold Seligman, Paris, and Mrs. Henry Walters. Sold, Sotheby Parke Bernet, New York, 26 April 1941, lot 681 (illustrated).

EXHIBITIONS: New York, China Institute in America, 1980–1981, *Chinese Porcelains in European Mounts*, cat. no. 5 (illustrated).

LITERATURE: William R. Johnston, "Precious Porcelains in Gilded Mounts," *Walters Art Gallery Bulletin* 21, no. 5 (February 1969); Pierre Verlet, "Alerubic, cassolette or brûle-parfum," *Ars Decorativa* 2 (1974): 107–115 (Budapest); illustrated, Lunsingh Scheurleer 1980, fig. 389.

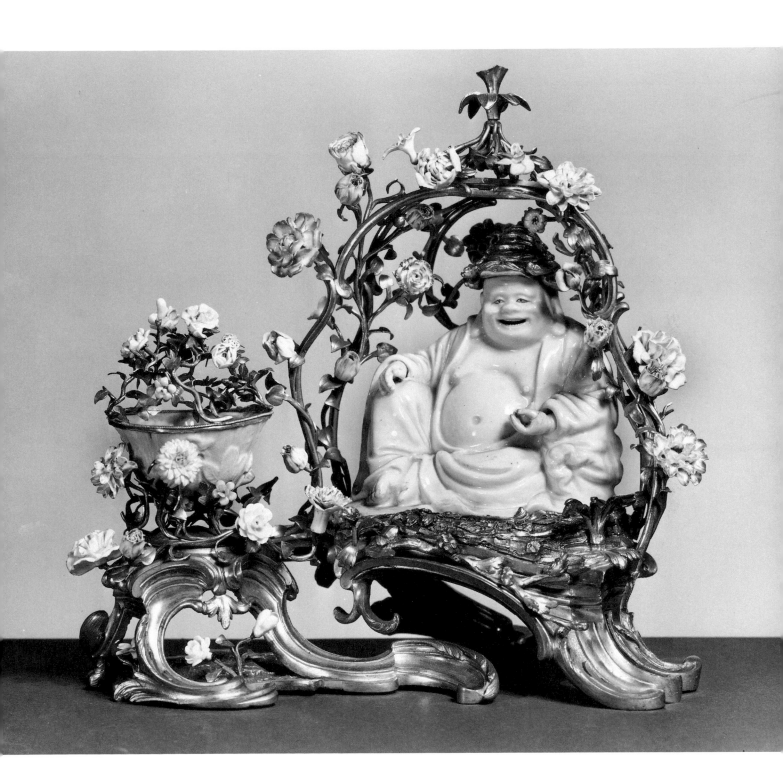

Mounted Vase

Porcelain: Chinese, Qing dynasty, 1700–1720
Mounts: French, gilt bronze, 1745–1749
12½ × 10½ × 14 (31.7 × 26.7 × 35.5)
The J. Paul Getty Museum, Malibu, California (79.DI.121)

One of a pair of Chinese porcelain vases of the Kangxi period enameled with *famille verte* colors and mounted around the mouth, the base, and at each side with handles of French gilt bronze. The porcelain dates from c. 1700–1720, the mounts from 1745–1749.

Formed from the lower part of a rouleau vase, originally about twenty inches high but cut down by almost half, the vase is enameled with green, blue, aubergine, and gilt. Sinuous horned dragons penciled in grisaille appear among the flowery, scrolling tree peonies. The band around the base alternates in squared, spiral, and basket-weave patterns on a green ground with four oval reserves enclosing peony sprays.

Rich, pierced, and flaring gilt-bronze mounts surround the mouth of the truncated vase. The foot is clasped by elaborately scrolled mounts entwined with floral and foliate sprays and supported on high feet in the form of elongated acanthus scrolls. These mounts are linked at each side by a scrolling handle from which sprays of bulrushes spring. Compare the mounts, except for those of the base, with the mounts of cat. no. 22 from The Frick Collection in New York. They are probably made by the same *fondeur*, although the Frick example is perhaps a little later in date.

Rouleau vases of the type from which the Getty vase was cut are not uncommon. Examples can be found in The Metropolitan Museum of Art in New York, the Freer Gallery in Washington, D.C., the Victoria & Albert Museum in London, and many other collections.

EXHIBITIONS: New York, China Institute in America, 1980–1981, *Chinese Porcelains in European Mounts*, 1980–1981, cat. no. 20 (illustrated).

LITERATURE: Gillian Wilson, *The J. Paul Getty Museum Journal* 8 (1980): 9, no. 6 (illustrated); Watson, Wilson, and Derham 1982, cat. no. 11 (illustrated).

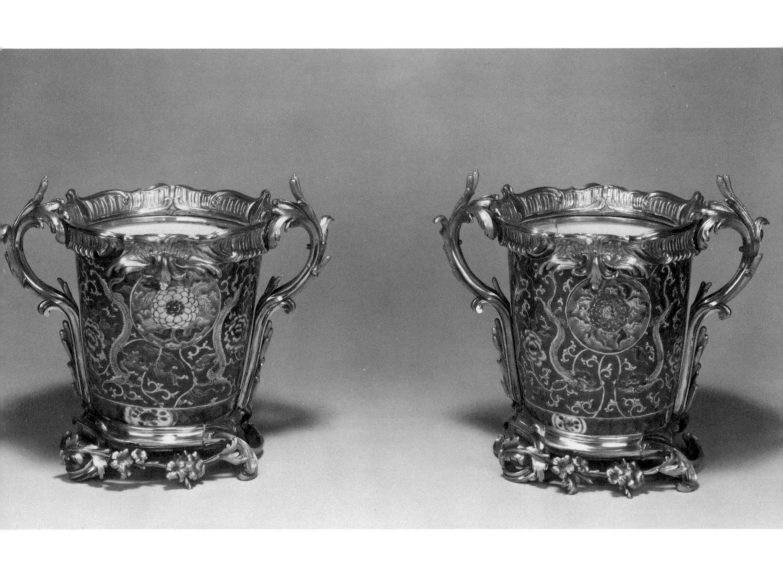

Vase Mounted as an Ewer

Porcelain: Chinese, Qing dynasty, c. 1720
Mounts: French, gilt bronze, 1745–1749
23⅝ × 8½ × 13 (60 × 21.5 × 33)
The J. Paul Getty Museum, Malibu, California (78.DI.9)

One of a pair of baluster-shaped vases of Chinese porcelain of the Kangxi period with tall trumpet-shaped necks. Both vases have been converted into ewers of European design by French gilt-bronze mounts in the rococo style. The porcelain dates from 1720, the mounts from 1745–1749.

The ground of the Yen Yen vases is a pale gray-green celadon painted with a thick white slip and underglaze copper red and blue with deer and storks among fungus, pine, and stylized flowering trees below clouds.

The glazed lip of each vase has been ground down and replaced by a large pouring lip of scrolled gilt bronze with applied sprays of flowers, leaves, and seed pods. A high scrolling handle entwined with similar floral sprays links the lip at the opposite side to the foot, which is raised on a high gilt-bronze base of openwork C-scrolls, acanthus leaves, and flowers that form the four feet. Two of the feet are struck with the crowned-C, indicating that they were probably made during the period 1745–1749. No. 16, possibly an inventory number, is also struck on one foot.

Many entries in the *Livre-Journal* of Lazare Duvaux record the sale of oriental porcelain vases converted into *buires* (ewers) by gilt-bronze mounts. A typical example is the sale to the marquise de Pompadour on 6 December 1751 of:

Deux autres vases en hauteur de porcelaine céladon ancienne, montés en forme de buire en bronze ciselé dorée d'or moulu, 1680 l[ivres].[1]

These ewers are rather above the average price, possibly because the mounts were of exceptional quality.

Another entry in the *Livre-Journal* provides further evidence of the cost of these ewers. On 15 July 1750 (and therefore at the precise period when the Getty ewer was mounted), Duvaux sold to the chevalier de Genssin:

La garniture en bronze doré d'or moulu de deux vases de la Chine, de quoi on fait deux buires, 288 l[ivres].[2]

Several ewers with similar mounts are known: the Louvre in Paris (cat. no. 406); the Wrightsman Collection at The Metropolitan Museum of Art in New York (cat. no. 244 a-b); and the James de Rothschild Collection at Waddesdon Manor (cat. no. 195). All have mounts very similar to the Getty ewers and are clearly from the hand of the same *fondeur*. Geneviève Levallet suggested that such mounts were the work of Jean-Claude Duplessis (working in Paris before 1742, died 1774),[3] but the evidence is inconclusive.[4]

Said formerly to have been in the collection of the duc de Cambacérès, but not listed in the inventory of the contents of his Paris residence taken after his death in 1824. The mark, no. 16, struck on the mount may refer to his ownership. Later in the collection of Henry Ford II. Acquired by the J. Paul Getty Museum at his sale, Sotheby Parke Bernet, New York, 25 February 1978, lot 56.

EXHIBITIONS: New York, China Institute in America, 1980–1981, *Chinese Porcelains in European Mounts*, cat. no. 28 (illustrated).

LITERATURE: Gillian Wilson, *The J. Paul Getty Museum Journal* 6–7 (1978–1979): 42, no. 6 (illustrated); Watson, Wilson, and Derham 1982, cat. no. 9 (illustrated).

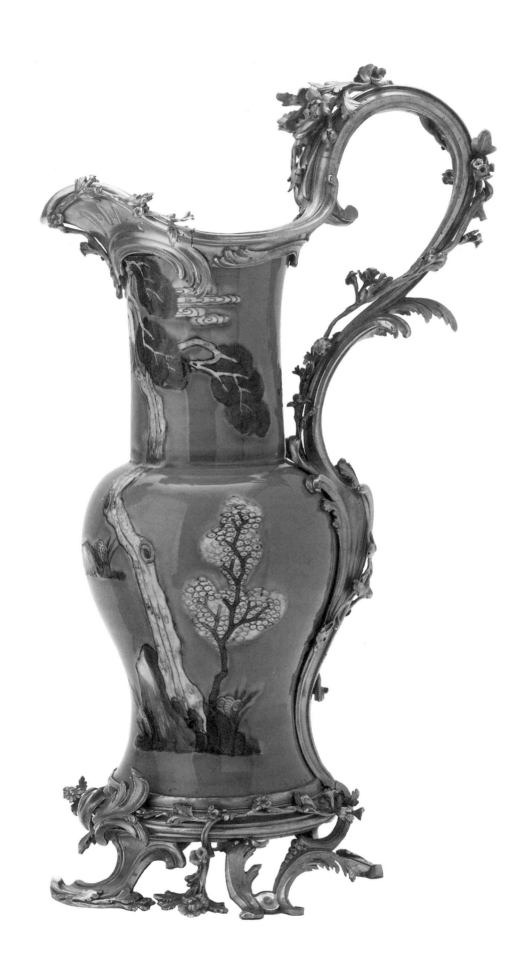

Lidded Vase Mounted as a Potpourri

Porcelain: Chinese, Qing dynasty, 1735–1750
Mounts: French, gilt bronze, 1745–1749
18 × 10 × 12½ (45.6 × 25.3 × 31.8)
The Fine Arts Museums of San Francisco (Palace of the Legion of Honor),
Collis P. Huntington Memorial Collection (1927.168)

The thick baluster-shaped vase, of gray crackle Chinese celadon porcelain of the Qianlong period, was originally covered by a high domed lid that has been cut down. A band of shaped medallions of brownish biscuit porcelain, incised with a fret design, encircles the vase below the neck and another above the foot.

The lid is separated from the body by a wide band of gilt bronze, which is pierced, scrolled, foliate, and combined with combed cartilaginous material below a narrow molding around the lower part of the lid. The lid is surmounted by a spiraling finial of flowers and leaves. The base of the vase rests on four high scrolling feet of gilt bronze of foliate and floral design. This foot is linked to the pierced band at each side by a high handle in the form of tall acanthus scrolls and berries that clasp the lower part of the vase and curve over to join with the pierced band.

The mounts are struck six times with the crowned-C: on the knob, twice on the pierced rim, on each of the handles, and on the base. They were almost certainly made in the years 1745–1749, although the mark could indicate merely that they were sold during that period. Nevertheless, their rococo style suggests such a date.

The surface of the vase, covered with innumerable irregular cracks is intended to imitate the famous Southern Ko craquelure. Such vases were not generally made for export, and this type of porcelain is very rarely mentioned in Duvaux's *Livre-Journal*. In France in the eighteenth century it was generally referred to as *porcelaine truittée* from a supposed resemblance to the markings on the body of that fish. Only when the craquelure was larger and coarser was it known as *porcelaine craquelée*.

On 17 December 1750 the marquise de Pompadour bought from Lazare Duvaux:

Deux vases de porcelaine truittée en forme de pot pourri, garnis en bronze doré d'or moulu, 1200 l[ivres].[1]

The cost of delivering them to her château de Bellevue between Paris and Versailles was 3 *l*(ivres).

Seven years later on 22 April 1757, the duc d'Orleans purchased from the same *marchand-mercier* a group of mounted vases of this same rare porcelain, comprising a large vase, two large potpourris, and two bottles, and was charged the considerable sum of 2960 *l*(ivres).

Several other potpourris and vases of this type are known, including a pair of vases in the Louvre in Paris (OA 6053; OA 6054) with mounts also struck with the crowned-C and a further pair in the Harewood collection in Yorkshire with dragon handles in the manner of Caffiéri. A pair of vases of the same type as cat. no. 20 in the Louvre[2] have been mounted as ewers very probably by the same *fondeur* who created the mounts for the potpourri.

The mounts have been attributed to Jean-Claude Duplessis (working in Paris before 1742, died 1774), but the evidence is inconclusive (see cat. 19, note 4). Insofar as his style in gilt bronze can be deduced from his designs for porcelain, the mounts of the Legion of Honor vase seem insufficiently sculpturesque. The mounts of a potpourri in The J. Paul Getty Museum[3] are much closer to those of the San Francisco potpourri.

LITERATURE: Illustrated, Lunsingh Scheurleer 1980, fig. 305.

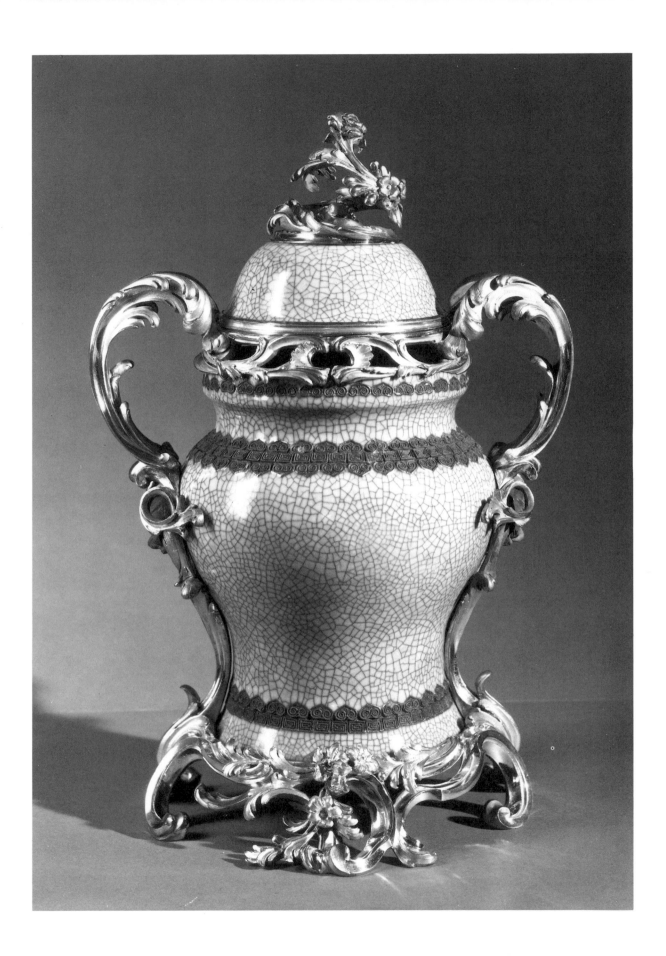

Pair of Vases Mounted as Ewers

Porcelain: Chinese, 1662–1722
Mounts: French, gilt bronze, 1745–1749
10¼ × 8 × 5¼ (26 × 20.2 × 13.3)
The Fine Arts Museums of San Francisco,
Collis P. Huntington Memorial Collection (1927.170; 1927.171)

The vases, circular and slightly bulbous in shape, are of Chinese porcelain of the Kangxi period. They are painted with tree peonies and birds in *famille verte* colors within four tall, shaped reserves on the sides. These reserves are separated by bands of bright green painted with flowers and above with scattered flowers and clouds on a darker green ground.

Each vase has been converted into an ewer by gilt-bronze mounts. The mouth of the vase is clasped by a deep lip with combed cartilaginous matter on the exterior and floral engraving within the burnished interior. Each lip is linked to a high double handle of scrolling leaves and flowers that clasps the lower part of the body, joining it to the high base that rests on four feet formed by scrolls, leaves, and flowers.

The mounts of each vase are struck with the crowned-C below the lip in front and on one of the feet.

It is rare to find mounted *famille verte* or *famille rose* porcelain mentioned in either Lazare Duvaux's *Livre-Journal* or contemporary sale catalogues. On the whole, either blue-and-white or monochrome porcelain was favored for mounting.

On 15 July 1750, just after the period when the San Francisco vases were mounted, the chevalier de Genssin had two Chinese vases (presumably supplied by himself) mounted as ewers by Duvaux:

La qarniture en bronze doré d'or moulu de deux vases de la Chine, de quoi on fait deux buires, 288 l[ivres],[1]
which gives some idea of the cost of the mounts.

LITERATURE: Illustrated, Lunsingh Scheurleer 1980, fig. 172.

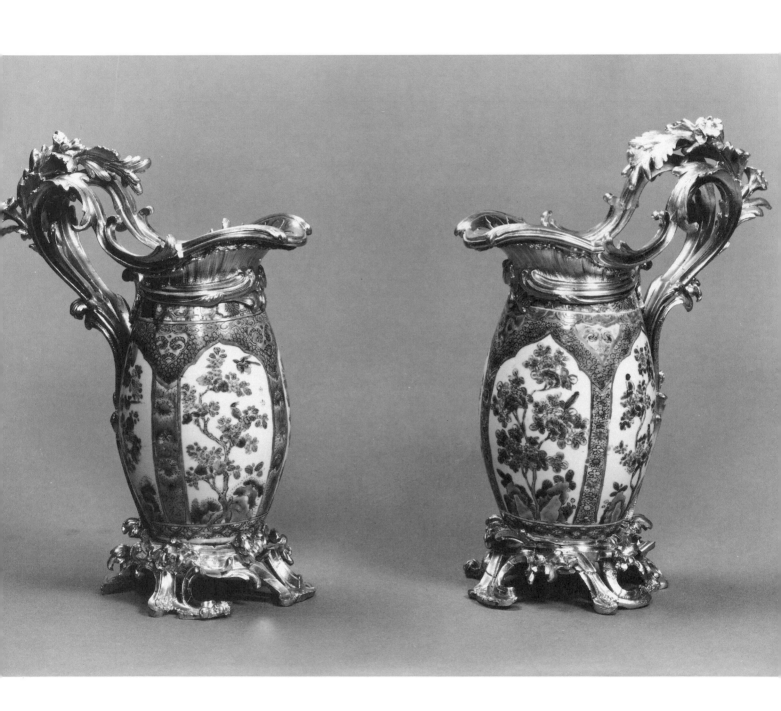

Pair of Lidded Jars

Porcelain: Chinese, Qing dynasty, 1723–1735
Mounts: French, gilt bronze, c. 1745–1749
17¾ × 8½ × 14¼ (45.7 × 19 × 24.1)
The Frick Collection, New York City (15.8.41; 15.8.42)

These baluster-shaped vases of dark blue Chinese porcelain of the Yongzheng period have short necks and are richly mounted on the lid, neck, foot, and sides with French gilt-bronze mounts dating from c. 1745–1749. Each vase has been cut from the lower part of the body of a tall vase with high shoulders and a flaring mouth. The lid of each was perhaps cut from the shoulders of the same vase.

The shallow domed lid is surmounted by a complex finial formed of gilt-bronze shells and coral resting on a flat circular base. The lid is separated from the body of the vase by a wide, convex, and slightly tapering band of gilt bronze, modeled with twisted flutes. From the center of this band, front and back, a prominent group of three leaves depends from a fan-shaped shell. At each side, the gilt-bronze band is linked to scrolling handles formed by rushes, berries, and acanthus leaves

that touch the body of the vase midway and are joined to the base by two short S-scrolls that terminate as feet. Twisted leaves form the other two feet at front and back.

The mounts are mostly struck with the crowned-C, suggesting that they were made during the period 1745–1749.

Compare cat. no. 18, whose mounts are of a similar character. They are probably by the same *fondeur-doreur*. Another very similar vase is in the Toledo Museum of Art,[1] but the gilt-bronze band has been pierced to adapt the piece as a potpourri. Others of more or less similar design are in the Wrightsman Collection (cat. nos. 246; 249).

The shell and coral finials on the lid are found on a number of mounted vases, specifically on a pair of potpourri bowls in the Wallace Collection (cat. nos. F 115 and F 116, where, under cat. no. F 112, their authorship is discussed). Cat. no. 36 has a similar finial.

What appears to have been a somewhat similar pair of mounted blue vases was in the Gaillard de Gagny sale, Paris, 29 March 1762:

41. *Deux Vases avec des couvercles de porcelaine, ancien bleu Turc, de 16 pouces & demi de haut. Ils sont posés sur des trépiéds, & ornés chacun de deux ances entrelassées, où se trouvent des roseaux: le dessus des couvercles est enrichi d'une platforme en ornement avec du corail, & une espece de conque de Triton: le tout de bronze, doré d'or moulu. Cette garniture est des plus agréables & bien exécutée.*[2]

They sold for 700 livres.

Formerly in the collection of H.M.W. Oppenheim. Sold, Christie's, London, 10 June 1913, lot 64. Bought by Henry Clay Frick from Duveen in 1915.

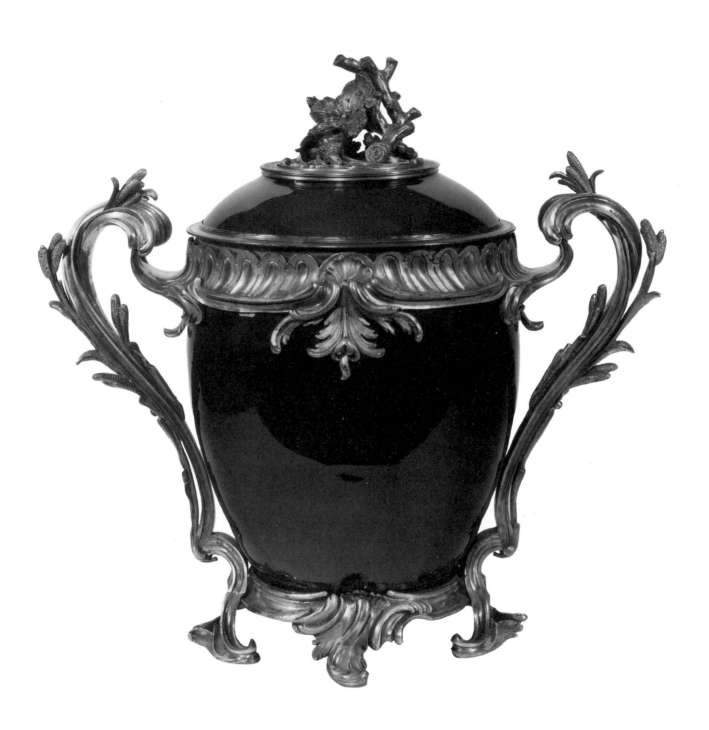

Potpourri

Lacquer: Japanese, c. 1730–1750
Mounts: French gilt bronze, 1745–1749
13½ × 12 × 18 (34.2 × 30.5 × 45.7)
The Fine Arts Museums of San Francisco,
Roscoe and Margaret Oakes Collection (54.70.1)

The circular bowl with a domed lid is decorated on all sides with open fans painted with floral sprays in *Togidashi Makie* lacquer of black and gold.

Between the bowl and the lid it has been mounted with a wide band of richly chased gilt bronze pierced with oval openings. Each opening is enclosed within two C-scrolls, between which grape clusters and vine leaves alternate with acanthus leaves. The foot of the bowl rests on a base of gilt bronze, supported on four feet of scrolled acanthus entwined with grape clusters and vine leaves. From this base at each side springs a gilt-bronze scroll of acanthus leaves, entwined with grape clusters and vine leaves, which forms the handles. Each handle splits at the top to join the pierced band in a pair of scrolls. The lid is surmounted by a finial in the form of a pine cone.

The mounts are struck with the crowned-C on the pierced band, the foot, and each handle, which suggests that the potpourri was made in the period 1745–1749. Only the finial that surmounts the lid is unmarked; it is a modern replacement.

In France, lacquer was much more rarely mounted in gilt bronze than was oriental porcelain. Thus, Lazare Duvaux sold only two pieces of mounted lacquer in the decade spanned by his *Livre-Journal*. The one most closely analogous to the example exhibited here is:

Une vase de laque rouge en forme de pot pourri, monté en bronze doré d'or moulu,[1]

which he sold to M. Boucher de Saint-Martin on 16 September 1749 for the considerable sum of 672 livres. In any case, lacquer appears seldom in the account book, although lacquer was imported into Amsterdam in large quantities by the Dutch, and the *marchands-mercier* were accustomed to purchasing most of their orientalia on the Amsterdam market.

The mounts may be compared with those of a pair of potpourris of mounted Imari porcelain in the Wrightsman Collection (see cat. no. 249 a–b), which have similar oval piercings enclosed within C-scrolls between lid and body and similar split handles although they lack the grape clusters and vine leaves. The Wrightsman Collection potpourris are perhaps by the same *fondeur-ciseleur*.

A smaller bowl of black and gold Japanese lacquer in The J. Paul Getty Museum has been mounted in silver in a style similar to the San Francisco example but as an *écuelle* (porringer) rather than a potpourri. The silver bears the Paris date letter for 1727–1738.[2]

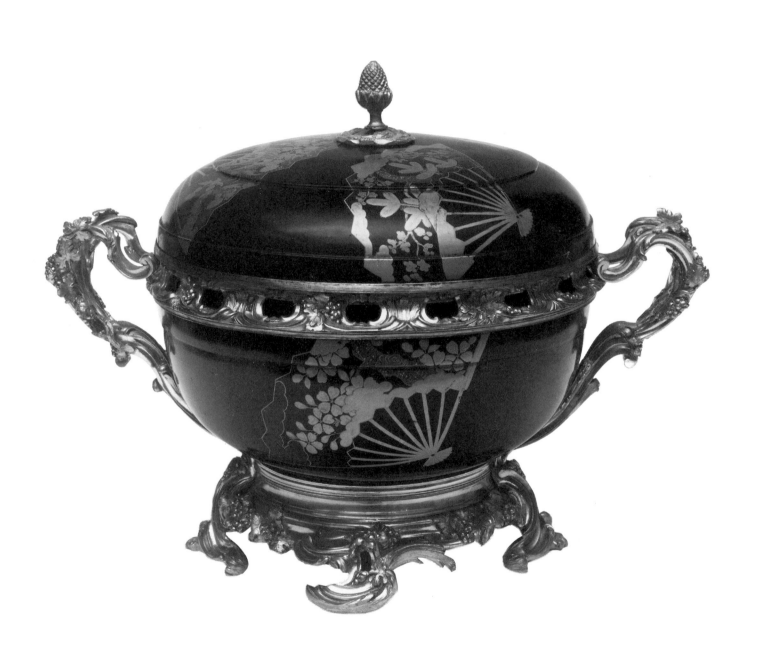

Ewer or Wine Pourer

Porcelain: Chinese, Ming dynasty, 1573–1619
Mounts: German, gilt bronze, mid-eighteenth century
11½ × 5⅟₁₆ (29.2 × 12.8)
Trustees of the Victoria & Albert Museum, London (29.1881)

This vase, of Chinese white porcelain from the Wanli period, has a globular body and a tall narrow neck with a flaring mouth and a knob midway and is enameled in *famille verte* colors with Chinese symbols taken from the Hundred Antiques. It has been adapted as a wine pourer by the addition of a lid, spout, handle, and base of gilt bronze.

The gilt-bronze mounts are of South German workmanship. The hinged lid, which clasps the slightly flaring mouth of the vase, is of oriental domed shape surmounted by a finial in the form of an acorn and with a split and scrolling thumb piece. The knob midway down the neck is clasped by a pierced band of gilt bronze between two narrower bands providing attachments for the spout and the handle. The tall spout, shaped like a swan's neck, emerges from the lower part of the vase, which has been pierced to receive it; the spout is attached to the band around the neck by an S-shaped scroll of gilt bronze. The scrolling handle on the opposite side of the vase is linked to the neck mounts by two addorsed C-scrolls and to the simple molding around the foot of the vase that, in turn, rests on a plain molded base ring of gilt bronze.

LITERATURE: Illustrated, Lunsingh Scheurleer 1980, fig. 76.

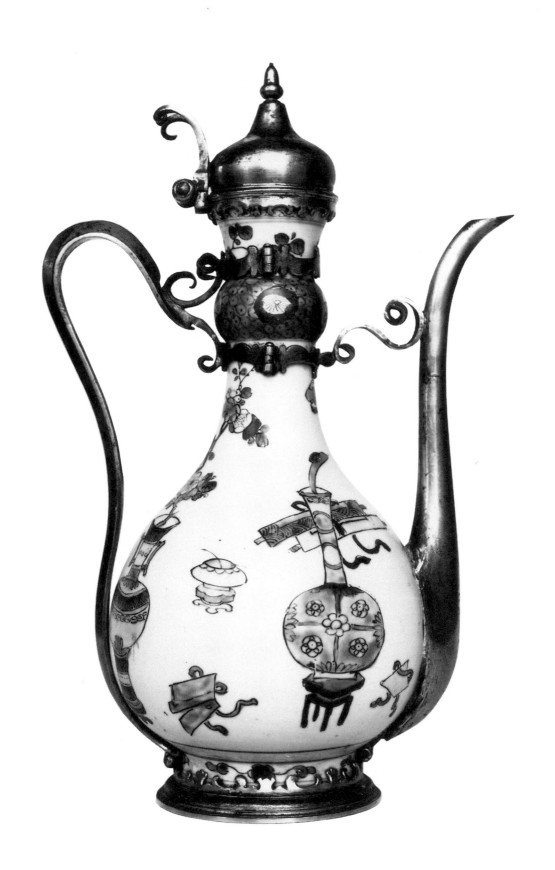

Mounted Vase

Porcelain: Chinese, Qing dynasty, 1662–1722
Mounts: Dutch, silver, mid-eighteenth century
$8\frac{3}{4} \times 4\frac{1}{2}$ (22.2 × 11.5)
Philadelphia Museum of Art, Philadelphia, Pennsylvania (43.51.5)

The baluster-shaped vase of Chinese porcelain of the Kangxi period has a short flaring neck and is painted in underglaze blue with three ladies in front of a pavilion and with a banana tree in a garden. The neck is painted with sprays of bamboo.

The neck, which has been cut or ground down, is clasped by a flaring mount of silver with an irregular lower border. It is engraved around the sides with groups of foliated design with fruits. The foot of the vase rests on a circular molded and splayed base engraved also with foliate motifs and supported on three feet of cartouche design.

Pair of Mounted Figures of Monkeys

Porcelain: Chinese, c. 1700–1725
Mounts: French, gilt bronze, c. 1750
8¼ × 5 × 6¾ (21 × 12.8 × 17.2)
8¼ × 5½ × 7¾ (21 × 14 × 19.7)
Alexander & Berendt, Ltd., London

Each Chinese porcelain monkey, of slightly grotesque character, sits on rockwork facing its companion and holding a Peach of Longevity in an outstretched hand. The mat surface of the bodies is striated and of a yellowish khaki coloring. The black rockwork is supported by another rockwork base of French gilt bronze dating from c. 1750. Leaves and moss grow on the gilt-bronze rockwork and a truncated tree springs from it in front of each monkey.

The monkeys are similar in size and pose but are not cast from the same mold. There is some doubt about their exact origin. When they were included in the sale of Baron Emmanuel Léonino's collection in 1937, they were described as being of Japanese pottery made at the Bizen factory. Today the consensus is that they are Chinese, made at the Yixing kilns in the early eighteenth century. Lazare Duvaux mentions monkeys of *terre des Indes* several times although none of them are mounted. Thus he

sold the marquise de Pompadour on 11 December 1750:

Deux singes de terre des Indes, 96 l[ivres].[1]

and to the duc de Tallard on 1 October 1751:

Un singe de terre des Indes ancienne, de 96 l[ivres].[2]

He also lists porcelain monkeys and other animals like cats with gilt-bronze mounts.

Two very similar monkeys, but without gilt-bronze mounts, were exhibited in Berlin in 1929.[3]

Formerly in the collection of Baron Emmanuel Léonino. Sold, Galerie Jean Charpentier, Paris, 18–19 March 1937, lot 170 (illustrated), to R. Weiller, Paris.

Potpourri Vase in the Form of a Shell

Porcelain: Japanese, Arita or early Hirado kilns, c. 1700
Mounts: French, gilt bronze, c. 1750
$6 \times 6\frac{1}{2} \times 7\frac{3}{8}$ (15.2 × 16.5 × 18.7)
The J. Paul Getty Museum, Malibu, California (77.DI.90)

One of a pair of Japanese celadon porcelain bowls of c. 1700 in the form of shells mounted as potpourris with pierced lids and handles of French gilt bronze of c. 1750.

The univalve conches of pale gray celadon porcelain (probably from Arita or the early Hirado kilns) rest on three porcelain feet in the form of clusters of coral. Smaller shells, barnacles, and other marine life encrust the shells' fluted bodies. The interior of each lip is enameled with blue and iron red. Each slightly domed gilt-bronze lid is designed as a pierced leaf of coral; its arched handle is in the form of a branch of seaweed. The lids fit into plain gilt-bronze rims. Each foot is shod with a gilt-bronze mount composed of coral, shells, and rockwork. The lids have a number of casting flaws.

In the Radix de Sainte-Foix sale, Paris, 22 April 1782, lot. 55 of the section Porcelaines d'Ancien Celadon is described as follows:

Deux coquilles singulières, à rebords coloriés d'un beau fond rouge, nuancé de bleu céleste foncé, garnies de couvercles, avec entrelacés à jour, bouton de coquilles, & trois pieds en rocaille de bronze doré. Hauteur 6 pouces, largeur 7 pouces.[1]

They were bought for 130 *livres* by the dealer Lebrun.

The size differs by only two or three millimeters from the Getty potpourri, so they are quite likely the very pair, one of which is exhibited here. The author is grateful to M. Dominique Augarde for bringing this reference to his attention.

It is conceivable, although less probable, that the Getty shell potpourris had previously been in the Jean de Julienne sale, although the Radix catalogue does not suggest so, nor are the dimensions of the de Julienne pieces known.

In the posthumous sale of the cabinet of M. de Julienne in 1767, lot 149 is described as:

Deux belles coquilles couvertes d'ancien & bon céladon uni, à rébords coloriés d'un beau fond rouge, elles sont de la plus grande perfection & garnies de bronze.[2]

A Japanese porcelain shell is listed in the inventory taken in 1740 after the death of the duc de Bourbon:

Une vase en forme de coquille, de porcelaine ancienne du japon, monture en bronze d'oré.[3]

Any of these pieces may have resembled the Getty shells, but other types of mounted porcelain shells are known.

In the inventory of the marquise de Pompadour's possessions, taken at her death in 1764, item 448 is:

Une coquille d'ancienne porcelain cassée, garny de bronze doré. Prise, trente six livres.[4]

The shell was stored in a cupboard on the first floor of the Hotel de Pompadour and was probably the same shell that Lazare Duvaux sold her on 4 September 1756:

Un grand vase de porcelaine céladon, à coquille, monté en bronze doré d'ormoulu de 60 louis, 1440 livres.[5]

Since that vase was described as large, more likely it resembled the mounted celadon shell in the Wrightsman Collection (cat. no. 243), which is almost a foot high. Also popular was another type of Japanese ceramic shell, which took the form of a snail shell and was fitted with a circular porcelain lid, with a smaller shell as a handle, also in porcelain. One, painted blue and simply mounted with three conical gilt-bronze feet, was sold in Paris in 1978 (Palais d'Orsay, 21 February 1978, lot 18). Compare cat. no. 30 for a pair of such shells of turquoise blue porcelain.

Several other such mounted porcelain shells are known. A pair of very similar shells, but with porcelain lids mounted in a gilt-bronze rim, are in the Residenzmuseum in Munich.[6] The lids appear to have had gilt-bronze handles, which are now missing. Compare cat. no. 16, a single porcelain shell, closely similar to the Getty shells but painted in polychrome colors and having a porcelain lid. It is more richly mounted with gilt-bronze shells, seaweed, coral, and rockwork.

EXHIBITIONS: Minneapolis, Minneapolis Institute of Art, 1977–1978.

LITERATURE: Gillian Wilson, *The J. Paul Getty Museum Journal* 6–7 (1978–1979): 37, no. 2; Watson, Wilson, and Derham 1982, cat. no. 13 (illustrated).

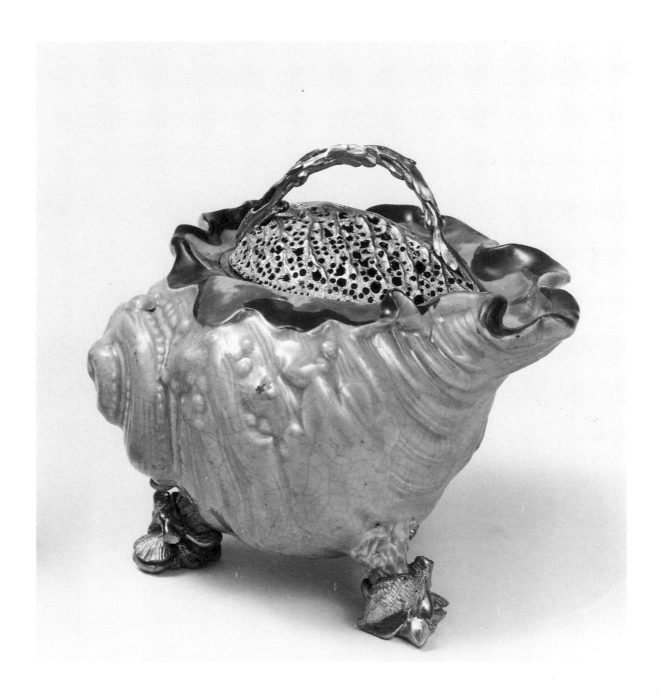

Chinese Figure Mounted as a Candelabrum with Porcelain Flowers

Porcelain: Chinese, Qing dynasty, 1662–1722
Mounts: French, gilt bronze, c. 1750, and painted metal
7¾ × 6¼ × 7¼ (19.7 × 15.9 × 18.4)
Didier Aaron Inc., New York City

This Chinese figure of Pu Tai Hosang, of yellow porcelain of the Kangxi period, is seated on a high scrolled, foliated, and pierced base of French gilt bronze of c. 1750. From the base behind the figure springs a two-branched tree of painted metal, to which are attached various flowers of French (probably Vincennes) porcelain. These branches spread on each side of the figure, and each supports on its end a candleholder and drip pan of foliated gilt bronze.

Numerous pieces of this type, with porcelain figures of diverse colors, were sold by the *marchand-mercier* Lazare Duvaux. Thus on 3 July 1755 this entry appears:

S.M. le Roy: Envoyé à Compiègne deux paires de petites girandoles à deux branches, dorées d'or moulu, sur des magots bleu-céleste, avec des fleurs de Vincennes même couleur, 528 l[ivres].[1]

Another entry dated 26 November 1753 gives some idea of the cost of mounting such objects. The *marchand-mercier* charged the marquise de Pompadour 192 livres for:

La monture en cuivre doré d'or moulu, à feuillages & terraces, de deux girandoles sur des magots gres.[2]

In creating such pieces, the *marchands-mercier* never hesitated to combine oriental with European porcelain (see cat. no. 17).

A number and variety of candalabra incorporating Chinese porcelain figures are known.[3]

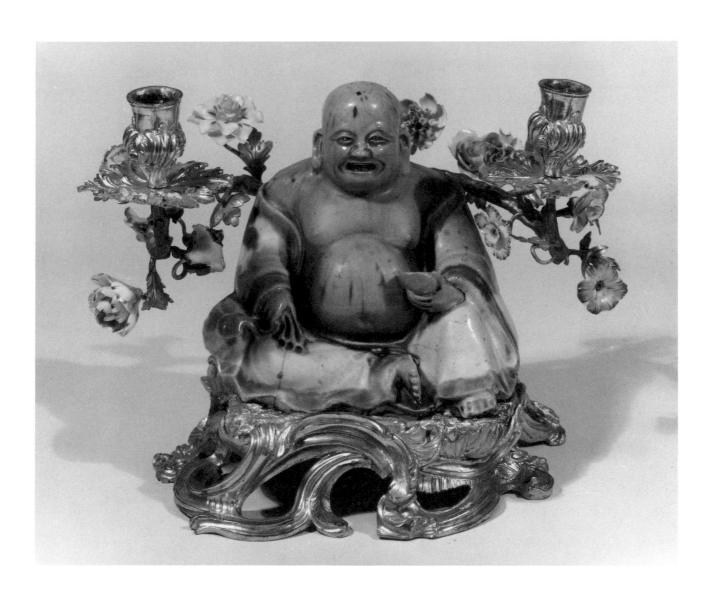

Pair of Mounted Vases

Porcelain: Chinese, Qing dynasty, first half of the eighteenth century
Mounts: French, gilt bronze, c. 1750
19⅝ × 10 × 13 (49.8 × 25.4 × 33)
Private collection, through Rosenberg and Stiebel, New York City

Each baluster-shaped vase of Chinese porcelain of the first half of the eighteenth century has a tall neck and squat bulbous body and is richly mounted with French gilt bronze of c. 1750.

The vases, of grayish crackle celadon (for discussion, see cat. no. 20), are painted in underglaze blue with groups of tree peonies and fruit on the sides of the body and with vertical sprays of flowers and leaves on the neck. They are not a matching pair: a narrow band of waves is painted in underglaze blue around the mouth of one vase; a band of scrolls encircles the other. Beneath the mounts clasping the neck, small porcelain handles, probably of animal form, have been cut off.

The vigorous gilt-bronze scrolls with which each vase is mounted clasp the mouth, rising high above the lip in three-sprayed acanthus-leaf motifs to form curving wavelike handles at each side. Below these scrolls depend further scrolls and acanthus leaves that clasp the neck. At the lower end these scrolls split and involute into further subsidiary circular handles above the shoulder of each vase.

Prominent scrolls, flowers, and cartilaginous matter of gilt bronze, which divide to form wide scrolled feet at each side, likewise clasp the base of the vase at each side.

The mounts are of a type often attributed to the sculptor and *fondeur* Jean-Claude Duplessis, but there seems little to support this attribution. The forms of his designs for Sèvres porcelain are bolder and more sculptural.

Formerly in the collection of the Earl of Harewood, Yorkshire. Sold, Christie's, London, 1 July 1965, lot 49 (illustrated).

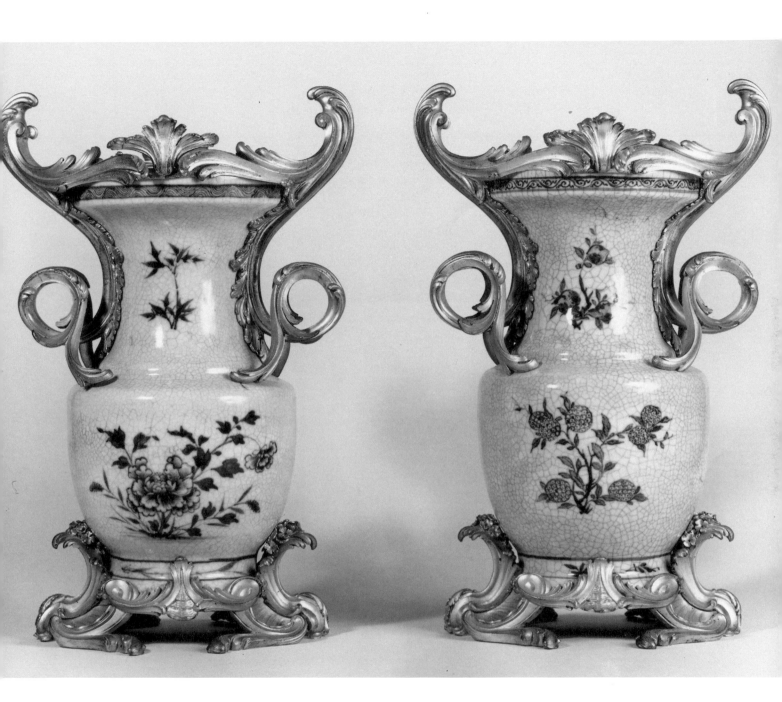

Pair of Turquoise Blue Shells

Porcelain: Chinese, Qing dynasty, 1662–1722
Mounts: French, gilt bronze, c. 1750
8¼ × 7 3/16 × 8¼ (21 × 18.3 × 21)
The Walters Art Gallery, Baltimore, Maryland (49.2255 a–b; 49.2256 a–b)

These vases are in the form of snail shells, or *Lo-ssus*, of turquoise blue Chinese porcelain of the Kangxi period with a crackle glaze. Each is mounted as a potpourri with French gilt bronze dating from c. 1750. The circular lid of the shell, with its finial in the form of a smaller shell, is separated from the body by a foliate and scrolled band of gilt bronze, pierced with circular holes to emit the aroma of the potpourri within. The shell itself rests on a raised gilt-bronze base whose sprays of leaves and seaweed are intermixed with prominent C-scrolls.

Porcelain shells were imported in considerable numbers into France in the eighteenth century (compare cat. nos. 16, 25). Both mounted and unmounted examples of this model are known, and it was already being copied in French porcelain at the Vincennes factory by c. 1750. A pair of these French porcelain shells are in the Forsyth Wickes Collection at the Museum of Fine Arts, Boston (65 Plate 1859 a–b; 65 Plate 1860 a–b).

The celebrated connoisseur and propagandist of neoclassicism, the comte de Caylus, owned an unmounted pair of Chinese porcelain,[1] as did the great English collector, Horace Walpole (Strawberry Hill sale, 25 April–24 May 1842, 11th day, lot 81). Curiously, no example of such a shell of Chinese porcelain is mentioned in the *Livre-Journal* of *marchand-mercier* Lazare Duvaux, although both French and oriental *blue turquoise* porcelain shells were particularly popular during the period covered by the account book.

EXHIBITIONS: New York, Wildenstein, Inc., 1967, *Treasures of the Walters Art Gallery*, cat. no. 146.

LITERATURE: Illustrated, Lunsingh Scheurleer 1980, fig. 283.

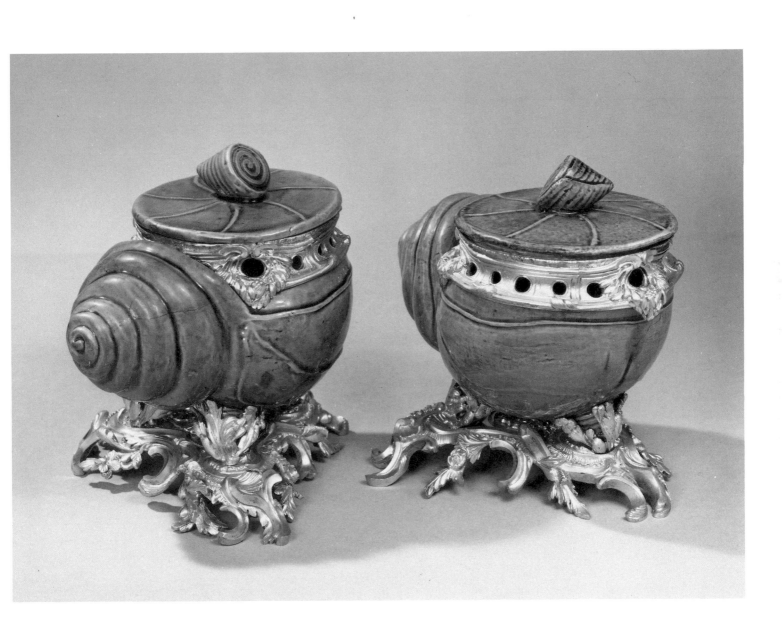

Pair of Perfume Burners

Porcelain: Chinese, Qing dynasty, c. 1700
Mounts: French, gilt bronze, c. 1750–1760
5⅛ × 6⅝ × 6¹⁵⁄₁₆ (13 × 16.9 × 17.7)
5 × 6¾ × 6⅜ (12.7 × 16.2 × 17.2)
The Metropolitan Museum of Art, New York City, bequest of George Blumenthal, 1941 (41.190.64 a–b; 41.190.65 a–b)

Each perfume of *blanc de Chine* porcelain from the Te-Hua kilns is now in the form of an octagonal pavilion with walls modeled in low relief with floral and geometric patterns. Each side has an arched door opening. The roof is of gilt bronze in the form of slanting openwork with a series of spindles between moldings, top and bottom, the lower one of foliate form. Within the top is a circular metal liner for the incense. The liner is lettered "b," while the roof itself is lettered "a." The pierced doors are framed with gilt-bronze moldings.

The whole rests on a shaped base of gilt bronze with an egg-and-dart molding around the upper edge and is supported on four feet in the form of oak leaves and acorns.

Originally the porcelain was perhaps designed as a censer, its handles and feet cut off, and the openings cut in the sides.

On 27 December 1756 Lazare Duvaux sold to the duchess de Mirepoix:

Une maison flamande formant une cassolette, ornée d'attributs, figures & animaux, 480 l[ivres].[1]

A Louis XIV clock mounted into a two-story house of Kangxi porcelain enameled in *famille verte* colors was sold at Sotheby's London, 2 July 1966, lot 22.[2]

Formerly in the collection of Alfred Sussmann. Sold Georges Petit, Paris, May 1922, lot 76 (illustrated), and given to The Metropolitan Museum by George and Florence Blumenthal, New York.

Pair of Ewers in the Form of Carp

Porcelain: Chinese, Qing dynasty, 1723–1735
Mounts: French, gilt bronze, 1750–1755
12⁷⁄₁₆ × 4¼ × 6⅜ (31.6 × 10.5 × 16.2)
National Gallery of Art, Widener Collection, Washington, D.C. (1942.9.443; 1942.9.444)

Each grotesque carp-dragon, of Chinese porcelain of the Yongzheng period with a pale cobalt glaze, has been mounted with French gilt-bronze scrolls, bulrushes, acanthus leaves, shells, and rockwork to adapt it as a pouring vessel or ewer with a high scrolled handle. The mounts date from 1750–1755.

The fish, with grotesquely protruding eyes, spout water or algae from their heavily toothed mouths (or are possibly grasping sacred pearls in their mouths), although the mounts that clasp the base conceal that fact. The mounts, which are in seven separate pieces screwed to an oval iron support below the base, take the form of bulrushes that spring from the foliated and twisted scrolls and shells forming the forefeet. At the back is a third foot, formed from rockwork, that supports a shell from which springs the tall scrolling handle running up the belly of each fish; it is entwined with bulrushes and acanthus leaves and is linked at the top to a split acanthus scroll that clasps the tail of the fish at one side. The other side of the tail forms the pouring lip of the ewer.

It is more usual for celadon fish to be mounted the other way up, with their mouths rather than their tails forming the pouring lip of the ewer. But a pair of fish similar to the examples from the National Gallery, although with different mounts, are in the collection of the Earl of Harewood, Yorkshire.

Such fish ewers—of a purely decorative character—were never intended for pouring liquids. Variant versions are frequently met, although generally the fish are of celadon porcelain. Thus on 27 June 1753 Lazare Duvaux sold to the famous patron of the arts (and of Watteau in particular) Jean de Julienne:

Deux poissons de porcelaine céladon, formant des cruches, montés en bronze doré d'or moulu, 960 l[ivres].[1]

Many more examples could be quoted. A particularly costly pair will suffice. On 17 October 1755 the *marchand-mercier* sold to Blondel d'Azincourt, *intendant* of the *Menus Plaisirs*:

Deux poissons aussi céladon montés en buires, 1800 l[ivres].[2]

Another pair of celadon fish similarly mounted but with the fish mouths at the top is in the Fine Arts Museums of San Francisco (1927.165; 1927.166). Many other examples are known, but few have mounts of the high quality of the National Gallery pieces. Double fish of celadon porcelain were also frequently mounted as ewers or vases. The Forsyth Wickes Collection in the Museum of Fine Arts, Boston, has a pair (65.2260; 65.2261).[3]

The mounts of a particularly fine baluster-shaped vase of green celadon porcelain in the Wallace Collection (cat. nos. F 105 and F 106) are certainly by the same *bronzier* as the National Gallery ewers. Some idea of the cost of such mounts alone is revealed in Lazare Duvaux's *Livre-*

Journal. On 9 February 1752 he supplied the marquise de Pompadour with:

Quatre pieds à contours en cuivre ciselé doré d'or moulu pour deux petits vases de porcelaine brune & deux poissons céladon (Cabinet de Versailles), 42 l[ivres].[4]

Even though these mounts were relatively simple, it is clear that the porcelain was generally the major component of the cost.

It has sometimes been suggested that such fish were originally mounted for the marquise de Pompadour and were an allusion to her family name, Poisson (a fish). This is in the highest degree unlikely; she was extremely conscious of her bourgeois origins and acutely aware that better-born courtiers made sarcastic allusions to her name.

Formerly in the collections of Lord Hastings, London; Duveen Brothers, Inc., New York and London; purchased from Duveen's, 1908, by P.A.B. Widener; inheritance from Estate of Peter A.B. Widener by gift through power of appointment by Joseph E. Widener, Elkins Park, Pennsylvania.

LITERATURE: Illustrated, Lunsingh Scheurleer 1980, fig. 331.

Mounted Vase

Porcelain: Chinese, Ming dynasty, 1368–1644
Mounts: French, gilt bronze, c. 1750–1765
19½ × 10 × 14 (49.5 × 25.4 × 35.5)
Anonymous loan

This vase of pale green Chinese celadon porcelain has a large body that swells in the lower part, where it is fluted, and tapers toward the wide mouth. A band of Chinese key-pattern in relief encircles the body above the fluting, interrupted front and back by a grotesque animal head in almost full relief. The lower part of the wide neck is surrounded by large vertical palm leaves also in relief, and around the mouth are shaped lappets below another band of Chinese key-pattern.

The mouth of the vase is clasped by acanthus scrolls of gilt bronze that curve up steeply at each side to link with the high, scrolling and split handles of involute shape. The handles rest on elaborate mounts of interlacing rushes and other aquatic plants, which spring from rockwork at each side of the foot and terminate below the handles, in an arched acanthus support. The foot of the vase rests on a base formed by sinuous acanthus scrolls of gilt bronze supported by four feet partly of acanthus and partly of rockwork.

This particularly fine mounted vase is related to several others. An example in the collection of the Earl of Harewood, Yorkshire, has the same upswept mounts around the mouth but lacks the handles. Also related are a group of vases of which the most familiar example is to be seen in a drawing (see cat. no. 49) that perhaps is part of the catalogue of the collection of Albert, Duke of Saschen-Teschen. These vases also lack the handles, and the drawing of the base suggests that it dates from later than cat. no. 33. Closest of the group to the present vase is one sold by Christie's, London, on 3 December 1981, cat. no. 33 (illustrated). Christie's catalogue lists five other closely related examples with slight variations. All take as their basic form important celadon vases of a type rarely exported from China, and the mounts of all were probably produced in the atelier of the same *fondeur*.

34 *Pair of Mounted Vases*

Porcelain: Chinese, Qing dynasty, 1736–1750
Mounts: French, gilt bronze, c. 1750–1765, attributed to Jean-Claude Duplessis (c. 1703[?]–1774)
18 × 8½ × 14¼ (46 × 21.6 × 36.2)
The Frick Collection, New York City (15.8.43; 15.8.44)

Each circular baluster-shaped vase, of dark blue Chinese porcelain of the early Qianlong period, has a short flaring neck. Traces of floral sprays and scrolls are painted in gold over the glaze. The blue glaze does not extend to the interior of the vase, which is glazed white. The neck of the vase has been cut down by several inches.

The neck is clasped by heavily scrolled and foliated mounts that rise at each side and curve inward in a wavelike manner. Smaller leaf motifs emerge from the scrolls and depend over the neck at front and back. The foot of the vase rests on a high base of similar scrolls that is supported on four feet. The feet at front and back take the form of three pendant leaves; those at the sides are large C-scrolls flanking rockwork over which water pours. These last mounts are linked to the lip by elaborately scrolled handles of foliate tree design that clasp the lower part of the body of the vase, split, and evolve into double-leaf scrolls that join the lip in S-shaped scrolls. From these scrolls emerge, midway up each side, a spray of leaves and berries that follow the curve of the scrolls at each side.

The mounts have been attributed to Jean-Claude Duplessis. The scrolling mounts of the Frick vase closely resemble a set of porcelain wall-lights that are generally accepted to have been modeled by Duplessis for the Sèvres factory where he worked from c. 1747 until his death in 1774. Duplessis certainly made mounts for

oriental porcelain. Lazare Duvaux mentions his work in this field frequently (see below), but no documented examples are known. The mounts Duplessis made or designed for Duvaux seem to have cost above the average. Thus the *marchand-mercier* sold to the marquis de Boyer on 13 September 1750:

Deux gros vases de porcelaine céladon montées par Duplessis en bronze doré d'or moulu, 3000 l[ivres].[1]

That this was not an exceptional price we see from an entry in the *marchand-mercier*'s account book four years later. On 16 March 1754 *fermier général* (tax farmer) Gaignat de Gagny bought:

Deux urnes de porcelaine céladon couvertes, montées en bronze doré d'or moulu par Duplessis, 2920 l[ivres].[2]

Another entry in the same year reveals the high cost of Duplessis's work. On 14 June 1754 this entry appears against the marquise de Pompadour's name:

La garniture en bronze d'oré d'or moulu de deux urnes de porcelaine céladon, modèles fait exprès par Duplessis, 960 l[ivres].[3]

And on the same day:

La garniture en bronze doré d'or moulu d'un vase en hauteur de porcelaine céladon à tête de bélier, nouveau modèle de Duplessis, 320 l[ivres].[4]

The difference in price between custom made mounts and those used in the ordinary course of the *marchand-mercier*'s commerce is also instructive.

That Duvaux did not make an excessive profit from his mounts is demonstrated by the following entry in his account book dated 21 August 1753, again charged to the marquis de Boyer:

La monture en cuivre ciselé d'une vase de porcelaine bleue, payée à M. Duplessis 720 l[ivres]—La dorure d'or moulu du dit vase, 192 l[ivres].[5]

Together these figures add up to a sum not far short of the 960 livres charged to the marquise de Pompadour and quoted above.

All the above entries in the *Livre-Journal* refer to the mounting of celadon porcelain, which may have added very slightly to the cost. In the eighteenth century it was widely but erroneously believed that celadon porcelain was of Japanese rather than Chinese origin. Since a much smaller quantity of Japanese porcelain was imported into Europe each year than came from China, its cost was correspondingly higher.

A like pair of vases with longer necks and closely similar though not identical mounts was formerly in the collection of Mme. Camille Lelong, Paris, and more recently on the New York art market.

Formerly in the collections of the marquesa de Foz, Lisbon, and H.M.W. Oppenheim. Sold, Christie's, London, 10 June 1913, lot no. 65. Acquired by Henry Clay Frick from Duveen in 1915.

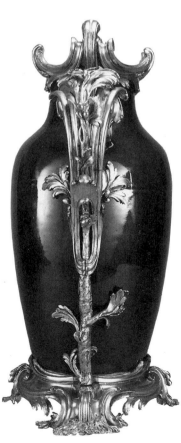

35 *Pair of Mounted Urns with Lids*

Porcelain: Chinese, Qing dynasty, 1736–1795
Mounts: French, gilt bronze, c. 1755–1765
18¼ × 7⅜ × 10½ (45.7 × 19 × 30.4)
The Frick Collection, New York City (18.8.45; 18.8.46)

The circular flaring body and low domed lid of each urn is of dark blue Chinese porcelain of the Qianlong period with traces of gilding over the glaze (see cat. no. 35). Each is richly mounted with French gilt bronze in the early neoclassic style. The handles at each side are in the form of infant Tritons with entwined double tails who are scrambling up the sides of the vase. Between them, front and back, hangs a heavy gilt-bronze swag of fruit and flowers.

The body of each urn is cut from the neck of a Yen Yen vase and inverted. The lids are perhaps formed from a deep dish of the same porcelain. A prominent bound laurel wreath, resting on a fluted cup also of gilt bronze, clasps the foot of each urn. This cup in turn rests on a tapering gilt-bronze support, chased around the sides with leaf motifs and resting on a square podium of gilt bronze that is chamfered around its upper edge.

A deep molding chased with wave-like scrolls encircles the lip of the urn, while a large finial of gilt bronze, in the form of two fluttering doves alighting on clouds, surmounts the lid.

The urns are each fitted with a tin liner of indeterminate date so that when the lids are removed the urns can be used as flower holders. Their main function, however, as with almost all French mounted oriental porcelain, was a purely decorative one.

Formerly in the collection of Sir John Fowler, London; sold by Duveen in 1915 to Henry Clay Frick.

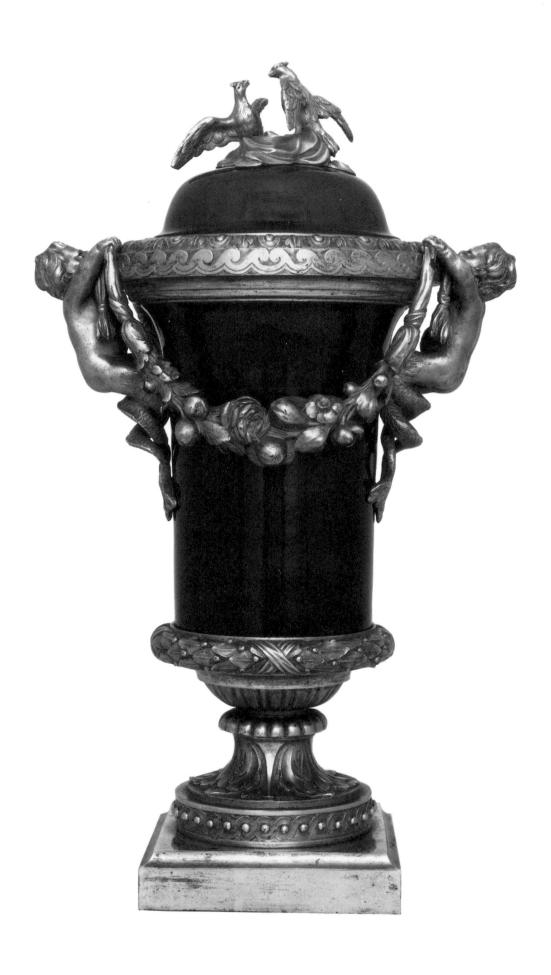

Mounted Vase

Porcelain: Chinese, Qing dynasty, 1662–1722
Mounts: French, gilt bronze, 1765–1770
20½ × 10¼ × 15⅜ (52 × 26 × 39)
Museum of Fine Arts, Boston, Forsyth Wickes Collection (65.2262 a–b)

This oviform vase of deep blue Chinese porcelain of the Kangxi period has been cut down from a *potiche* with a flaring mouth and given a lid probably cut from the shoulder below the trumpet-shaped neck of a vase of matching porcelain. It has been richly mounted with French gilt-bronze mounts in the rococo style to form a decorative vase of European character.

A high gilt-bronze base with four feet of scrolling and foliate form supports the foot of the vase. At each side, tall scrolling handles entwined with a floral spray spring from the base. The handles link the base to a wide band of gilt bronze that separates the vase from its lid and that is modeled with twisted flutes and enriched at front and back with a cluster of flowers, leaves, and C-scrolls. The lid, domed in two tiers, is surmounted by an elaborate knob of shells, seaweed, and coral, all of gilt bronze and resting on a circular base.

The *marchand-mercier* Lazare Duvaux sold a number of mounted vases that must have been much like this in character. Thus on 6 December 1751 he sold to the marquise de Pompadour:

Une vase d'ancienne porcelaine bleue imitant le lapis, garni en bronze d'oré d'or moulu, 1320 l[ivres].[1]

An idea of the cost of such mounts and their gilding can be obtained from a sale he made to the marquis de Voyer on 21 August 1753:

La monture en cuivre ciselé d'un vase de porcelaine bleue, payée à M. Duplessis, 720 l[ivres]—*La dorure d'or moulu du dit vase, 192 l*[ivres].[2]

Cutting the vases to adapt them to European shapes could be a costly procedure. Thus on 30 December 1751, the great patron of the arts, Jean de Julienne, bought from Lazare Duvaux:

Quatre grands vases de porcelaine bleue à cartouches, de 24 louis 576 l[ivres].[3]

and gave the following instructions:

avoir coupé les vases & fait des pieds & gorges à moulure & godrons dorés d'or moulu, 216 l[ivres].[4]

The mounts have been attributed to Pierre Germain, who was not a metalworker. He published a set of engravings, "Eléments d'Orfèverie" (1748), in which features similar to the knob of the Boston potpourri are found. The mounts have also been attributed to Jean-Claude Duplessis, to which the second of the above quotations from Lazare Duvaux's *Livre-Journal* might seem to give some support. However, a finial of almost exactly the same form appears on the silver lid of a *sucrier* (sugar bowl) from the Necéssaire de Voyage of Queen Marie Lesczinska, which bears the Paris date mark for 1729–1730. Thus any such attribution is hazardous.

A number of similar vases exist in which the twisted fluting of the gilt-bronze band that separates the lid from the base is pierced to make it usable as a potpourri.[5]

For a very similar mounted vase, possibly from the workshop of the same *bronzier*, see cat. no. 22.

Formerly in the collection of the marquis de Ganay, Paris, and Forsyth Wickes, Newport.

LITERATURE: Illustrated, Lunsingh Scheurleer 1980, fig. 272.

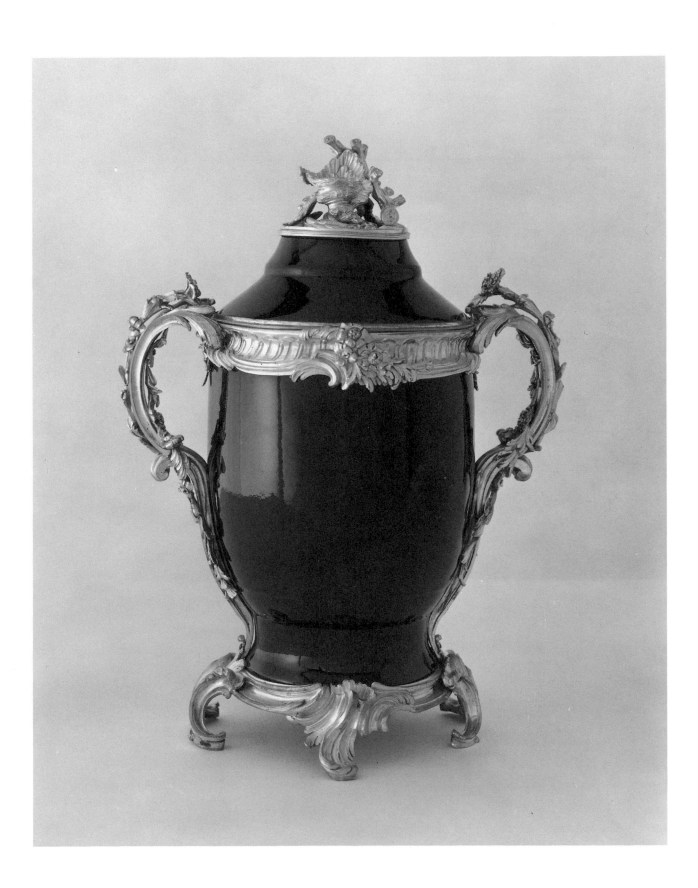

Pair of Threefold Gourd-Shaped Blue Vases with Mounts

Porcelain: Chinese, Qing dynasty, 1736–1795
Mounts: French, gilt bronze, 1765–1775
10¾ × 5 (27.4 × 12.8)
The Walters Art Gallery, Baltimore, Maryland (49.1778 a–b; 49.1779 a–b)

Each vase consists of a waisted bottle in the form of molded, lobed double gourds of turquoise blue Chinese porcelain of the Qianlong period with a crackle glaze. Each is mounted around the waist, mouth, and foot with French gilt bronze in the early neoclassic style.

A feigned drapery of gilt bronze is knotted around the waist of each bottle; its tasseled ends hang down the side of the lower section of the body. The neck is enclosed in a molding of gilt bronze, from which depend swags of a tasseled drapery caught up at intervals by pendant tassels. A handle in the form of a rose wreath rises from the front edge of the lid.

Each bottle rests on a circular base of gilt bronze of neoclassical design, reeded around the edge and supported on three short, tapering, and fluted feet.

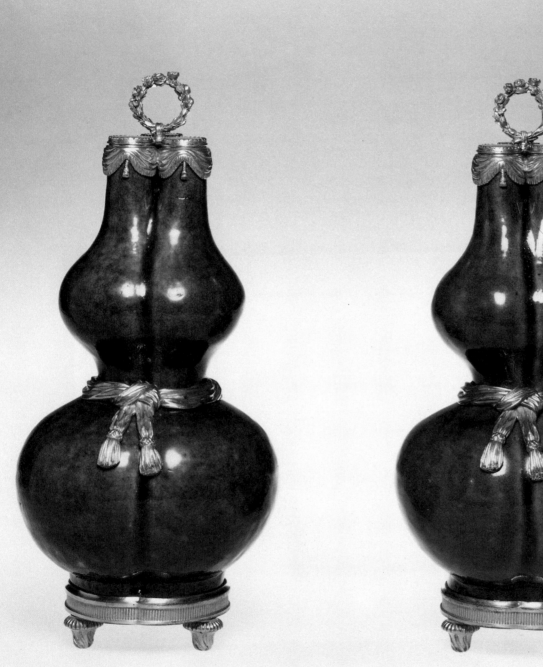

38 *Pair of Mounted Celadon Urns*

Porcelain: Chinese, Qing dynasty, 1662–1722
Mounts: French, gilt bronze, c. 1775–1785
$12\frac{5}{8} \times 8\frac{1}{2}$ (32 × 21.6)
$12\frac{13}{16} \times 8\frac{1}{2}$ (32.5 × 21.6)
The Detroit Institute of Arts (59.131; 59.132)

Each trumpet-shaped urn is of green Chinese celadon porcelain of the Kangxi period. Incised beneath the glaze are scrolling branches of tree peonies in full bloom. Each urn has been cut down from the neck of a tall baluster-shaped Yen Yen vase and mounted with a lip and foot of French gilt bronze in the full neoclassical style dating from c. 1775–1785.

A thick wreath of laurel leaves bound with ribbon clasps the lip of each urn. At each side, a pendant handle, consisting also of a laurel wreath, is attached by a feigned ribbon bow. The foot of the vases, around which the central fluting of the original vases can be seen, is set in a gadrooned cup of gilt bronze, supported on a splayed foot of fluted neoclassic design that rests on a plain square plinth. The mounts, with their heavy laurel wreaths, recall the work of designer Charles Delafosse (1734–1789).

A somewhat similar pair of urns of deep blue porcelain, but with figural mounts and a lid, is in The Frick Collection, New York (see cat. no. 34).

On 3 October 1753 Lazare Duvaux sold to the marquise de Pompadour:

Deux vases couverts, forme d'urne avec des anneaux, de porcelaine céladon, garnis de terrasses, cercles & bonnets dorés d'or moulu, 864 l[ivres][1]

that no doubt resembled those shown here, but their mounts would have been in a more rococo style. Possibly the urns shown here also had lids originally.

EXHIBITIONS: New York, China Institute in America, 1980–1981, *Chinese Porcelains in European Mounts*, cat. no. 12 (illustrated).

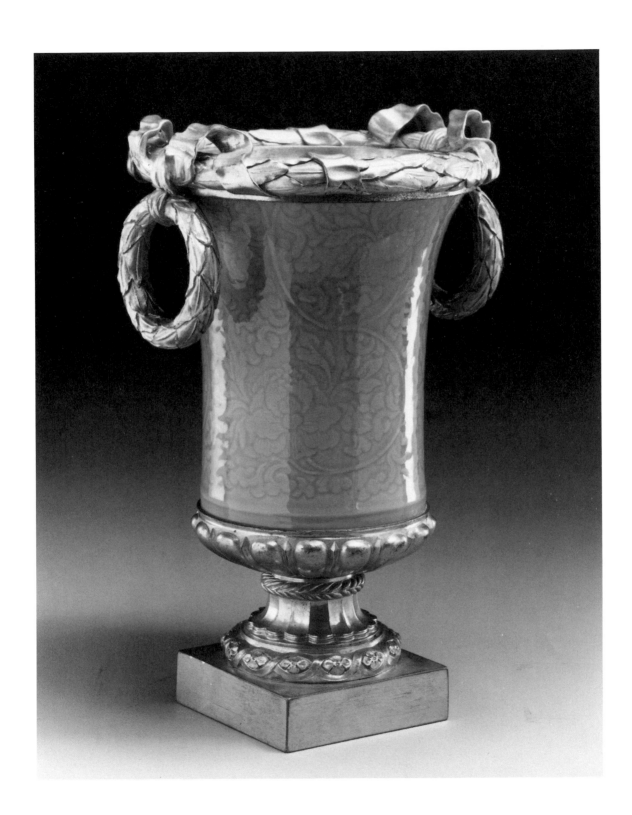

Pair of Long-Necked Vases Mounted as Ewers

Porcelain: Chinese, Qing dynasty, mid-eighteenth century
Mounts: French, gilt bronze, 1780–1785
24⅛ × 9¹¹⁄₁₆ (61.2 × 24.6)
National Gallery of Art, Widener Collection, Washington, D.C. (1942.9.441; 1942.9.442)

Each piece is in the form of a vase, with a globular body and a tall neck of pale green Chinese celadon porcelain, decorated in white underglaze slip possibly of the Qianlong period. Each has been adapted as an ewer of European design, with French gilt-bronze mounts of neoclassic character dating from 1780–1785.

The porcelain is decorated with designs of trees and flowers in white underglaze slip. Each vase is supported on a high circular and tapering gilt-bronze foot encircled with inverted acanthus leaves; on this foot rests a cup with alternating flutes and bellflowers that clasp the base of the vase. Springing from one side of the cup is a tall handle in the form of a double-tailed mermaid with upraised arms that terminate in leaf trails instead of hands. The leaf trails wind around the scrolling handle and link the foot to the unusually high lip. The lip, highly polished in the interior, has on its underside a large, finely modeled mask of Bacchus emerging from acanthus leaves in the manner of a gothic woodwose. Vine leaves and grape clusters depend beneath the lip all around the neck.

Oriental porcelain with mounts of neoclassical design are much rarer than those with rococo mounts (see Introduction). The chasing of the National Gallery ewers is of exceptionally refined quality.

A pair of similar but smaller and more simply mounted ewers was in the George Blumenthal collection in New York. Sold, Galerie George Petit, Paris, 1 and 2 December 1932, lot 90 (illustrated, plate XLV). Their mounts were probably the work of the *fondeur* who made the National Gallery ewers.

In spite of the Bacchic symbolism, such ewers were created for decorative purposes and were never intended to hold wine.

Formerly in the collections of the marquis de Montault, Château de la Terte, Trescuel, L'Aigle, Normandy; Charles Wertheimer, London; Duveen Brothers, Inc., New York and London; purchased from Duveen's, 1912, by P.A.B. Widener; inheritance from Estate of Peter A.B. Widener by gift through power of appointment by Joseph E. Widener, Elkins Park, Pennsylvania.

LITERATURE: Illustrated, Lunsingh Scheurleer 1980, fig. 344.

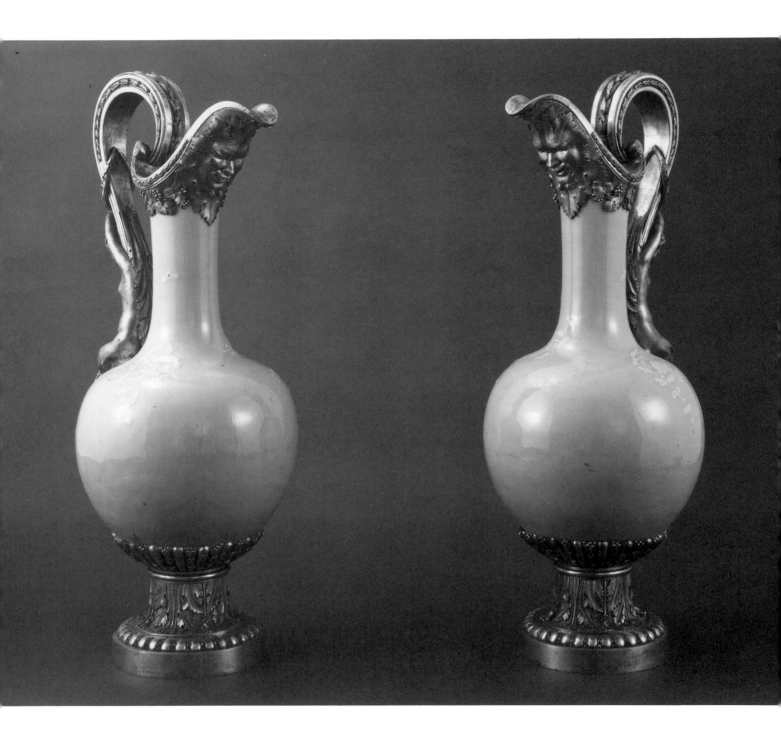

Garniture de Cheminée

Porcelain: Chinese, Qing dynasty, 1650–1670
Mounts: French, gilt bronze, 1780–1785
12⅞ × 4½ (32.8 × 11.5)
14¾ × 5⅞ (37.5 × 15)
13 × 4½ (33 × 11.5)
The Detroit Institute of Arts (28.83; 28.85; 28.84)

The garniture consists of three matching cylindrical lidded vases of white Chinese porcelain painted in underglaze blue with tree peonies, birds, water plants, and vases. The central vase is slightly taller than the other two. The porcelain is of the Kangxi period, dating from 1650–1670. All three vases are similarly mounted with French gilt bronze in an advanced neoclassic style dating from 1780–1785.

In France such garnitures were intended to stand on the shelf of a chimney piece or the top of a commode.

Cut down from tall rouleau vases, the shoulders and neck of each vase have been removed. A neck of gilt bronze, chased with interlaced bands, ovoli, and laurel leaves, has been inserted between the cut top of the vase and the lid that has itself been mounted with a foliate knob of gilt bronze. From the neck, heavy laurel swags and pendants hang, caught up at the cardinal points with feigned nails. On the taller central vase, the swags are caught up over a mask of Bacchus at each side. The foot of each vase rests on a gilt-bronze base that is embellished with moldings, ribbed bands, and acanthus leaves. The foot of the central vase, taller than the other two, as is its neck, is fluted and rests on a shaped, four-sided plinth chased with panels of ribbing.

The quality of the vases is exceptional for export porcelain. In view of the long period between the date of the porcelain and the date of the mounts, it is not impossible that these vases were among the many pieces of blue-and-white porcelain brought as gifts to Louis XIV, his family, and court in 1683 (see Introduction). The Grand Dauphin's collection, consisting principally of large quantities of blue-and-white porcelain, was dispersed after his death in 1712, at which time many pieces passed into the hands of private collectors and were subsequently mounted.[1]

Formerly in the collection of Lord Grimthorpe.

EXHIBITIONS: Detroit, The Detroit Institute of Arts, 27 April–3 June 1956, *French Taste in the Eighteenth Century*, cat. no. 128A (illustrated); New York, China Institute in America, 1980–1981, *Chinese Porcelain in European Mounts*, cat. no. 24 (illustrated).

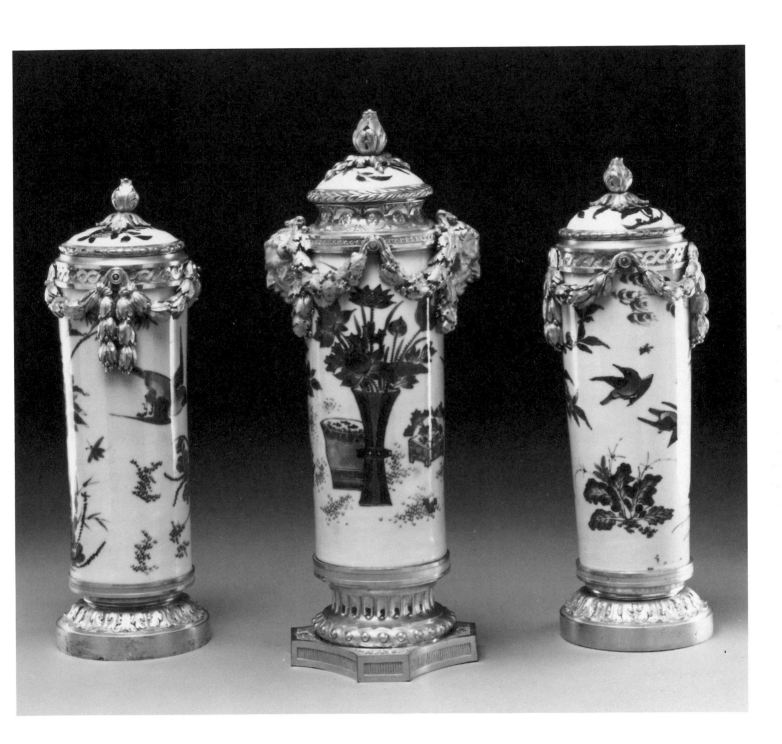

Pair of Vases Mounted as Ewers

Porcelain: Chinese, Qing dynasty, 1723–1735
Mounts: French, gilt bronze, first half of the nineteenth century (?)
17 × 7½ (43.1 × 19)
The Walters Art Gallery, Baltimore, Maryland (49.1565; 49.1566)

Each piece consists of a vase of *sang de boeuf* Chinese porcelain of the Yongzheng period, with a globular body and long neck that has been converted into an ewer of European type by the addition of French gilt-bronze mounts of uncertain date.

The mounts comprise a rocky base from which rise bulrushes that clasp the base of the vase. The pouring lip is formed by the spread wings of a gilt-bronze swan resting on rushes clustered around the mouth of the vase. Each swan attempts to eat the uppermost leaves of a long spray of wind-blown rushes that springs from the vase, clings to its side, and, together with the swan's head and curving neck, forms the handle. The design is unusual and perhaps too romantic to date from the eighteenth century, although such swans form part of the mounts of a turquoise blue shell of seventeenth-century Chinese porcelain, once Marie Antoinette's and now in the Louvre (OA 5182).

Purchased from the Paris dealer E.M. Hodgkins by Henry Walters.

LITERATURE: S. W. Bushell, *Oriental Ceramic Art* (New York, 1899), vol. 1, p. 819, fig. 15.

Boat-Shaped Porcelain Drinking Vessel

Porcelain: Chinese, Ming dynasty, c. 1500
Mounts: Southeast Asian, silver, nineteenth century(?)
8³/₁₆ × 3⅝ × 8³/₁₆ (20.8 × 9.3 × 20.8)
Visitors of the Ashmolean Museum, Oxford, England (1969.88)

This crescent-shaped body of Chinese porcelain, made for export to Southeast Asia, is painted in underglaze blue with clouds, lattice-work, and floral scrolls. It is mounted as a drinking vessel of a Far Eastern type with Malay silver of undetermined (although probably nineteenth-century) date.

The porcelain body is of flattened oval section with longitudinal ribs and a flat unglazed base, and it rests on four lappet feet. It is pierced at the top center with a circular hole that is mounted with a tall hollow column of embossed silver surmounted by a domed lid with a ball-shaped finial. Each horn of the crescent is also mounted with a circular and tapering cap of embossed silver with a ball-shaped finial. The horn at one end has been pierced and fitted with a short fluted spout below the mount. Its flat circular lid is attached by a long silver chain to the silver mount of the adjacent horn. The domed lid of the central column is similarly chained to the other horn mount.

R.H. Pinder Wilson and M. Tregear have connected this unusually shaped vessel with a similarly shaped one of leather shown in an Indian (probably Deccannese) painted miniature in the Museum of Fine Arts, Boston, dating from 1605–1615, and with a similarly shaped Indian vessel of bronze from the late sixteenth or early seventeenth century now in the British Museum. Another appears in an Indian (Mughal School) painted miniature of about the same date, which is in a private collection.

These authors suggest that the rather curious shape derives from the forequarters of an animal skin used to carry water when traveling, with the stumps of the forelegs forming the horns of the vessel and the head forming the central column. The vessel was filled at the center; the contents poured from the spout at one end.

Chinese porcelain *kendi* (see cat. nos. 2, 6) were often mounted with silver in Malaysia, but vessels of the type of the Ashmolean drinking vessel are rare. Another with bronze mounts of a much simpler design is in the City Art Gallery, Bristol.

LITERATURE: R.H. Pinder Wilson and M. Tregear, "Two Drinking Flasks from Asia," *Oriental Art* XVI, no. 4 (Winter 1970): 337–341; illustrated, Lunsingh Scheurleer 1980, fig. 588.

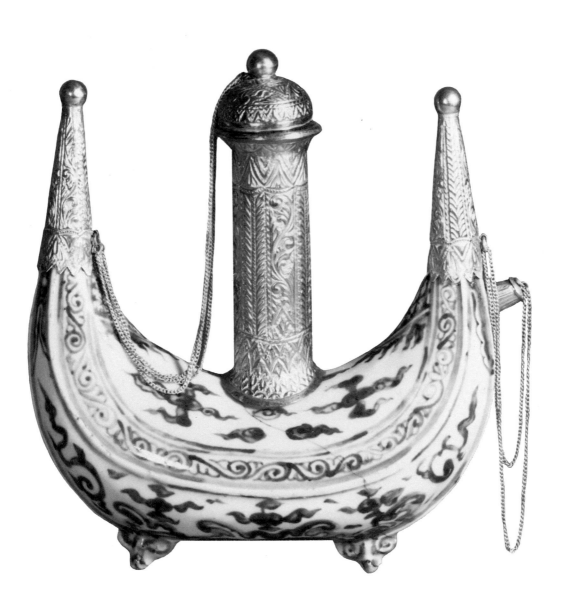

43 *Ewer*

Porcelain: Chinese, Qing dynasty, 1662–1722
Mounts: Turkish, engraved brass, nineteenth century
13⅜ × 10⅝ (34 × 27)
Trustees of the Victoria & Albert Museum, London (476.1876)

This porcelain wine pourer of Chinese porcelain of the Kangxi period has a globular body and tall flaring neck and is painted on the sides with tree peonies and leaf sprays in underglaze blue within a quadrilobe reserve. It was mounted in Turkey as an ewer or water jug.

The neck is entirely enclosed in brass that is elaborately engraved with an Arabic inscription above a roped annular ring and with scrolling flowers and leaves on the lower part. Shaped and lobed frames enclosing birds are interspersed among the scrolling. Pierced lappets or leaf forms depend below the neck mount. The mouth of the vessel has a domed lid surmounted by a flaring finial. The lid is engraved similarly to the neck and hinged to the curving handle, which is square in section and engraved on the sides with fleurons alternating with flowers. Opposite the handle springs a tall swan's neck spout enclosing the original porcelain spout but extending beyond it. The spout is engraved with flutes and flowers, the lower end with birds and animals. The horizontal metal mouth terminates in an elaborate shield-shaped stopper.

A similar ewer of mounted Chinese blue-and-white porcelain, the mounts probably from the same Turkish workshop, is in the Berlin Museum Far Eastern Collection (Ch.K. 170/21).[1] Chinese porcelain had been coming to the Near East, both by sea and land, for many centuries before it began to reach the West in any quantity.

44 *Pair of Mounted Rouleau Vases*

Porcelain: Chinese, Qing dynasty, 1662–1722
Mounts: Probably German, gilt bronze, c. 1860–1870
23½ × 11⅛ × 12 (59.7 × 28.2 × 30.6)
The J. Paul Getty Museum, Malibu, California (78.DI.240.1; 78.DI.240.2)

These rouleau vases of Chinese porcelain of the Kangxi period have tall cylindrical necks and are glazed with *bleu soufflé* (powder blue). Each is richly mounted with gilt bronze in an exuberant rococo style around the neck, on the body, and at the foot.

The neck of each vase is encircled by an elaborately scrolled and pierced gilt-bronze lip, which is linked to the shoulders by handles in the form of double C-scrolls that are joined below the shoulders to a twisted cabochon cartouche within prominent twisted motifs of flamelike gilt bronze at the center front and back. Below the handles, pendant C-scrolls entwined with flowers and leaves clasp the vase. An elaborately scrolled and pierced base, with foliations and aquatic motifs supported on four richly scrolled feet, clasps the foot of each vase.

A pair of underglaze blue vases of Berlin porcelain sold at Sotheby's, London, on 3 November 1976 had gilt-bronze mounts of the same exuberantly rococo character that were signed "Bormann," suggesting that

they were of German origin. It seems likely that the mounts of the Getty vases are German also. The Sotheby examples were described as c. 1890. Nothing is known of the *bronzier* Bormann.

As with many of the pastiches of eighteenth-century gilt bronze made in the last quarter of the nineteenth century by the Paris firm A. Beurdeley & Cie., and others specializing in the reproduction of eighteenth-century French furniture and decorative arts objects, the mounts, particularly their chasing, are of very high quality and extremely deceptive to the eye.[1]

Formerly in the collection of Mrs. Evelyn St. George. Sold at her sale, Sotheby's, London, 24–25 July 1939, lot 81, to J. Paul Getty and given by him to The J. Paul Getty Museum. Currently on loan to the National Trust for Historic Preservation at Fioli, San Francisco.

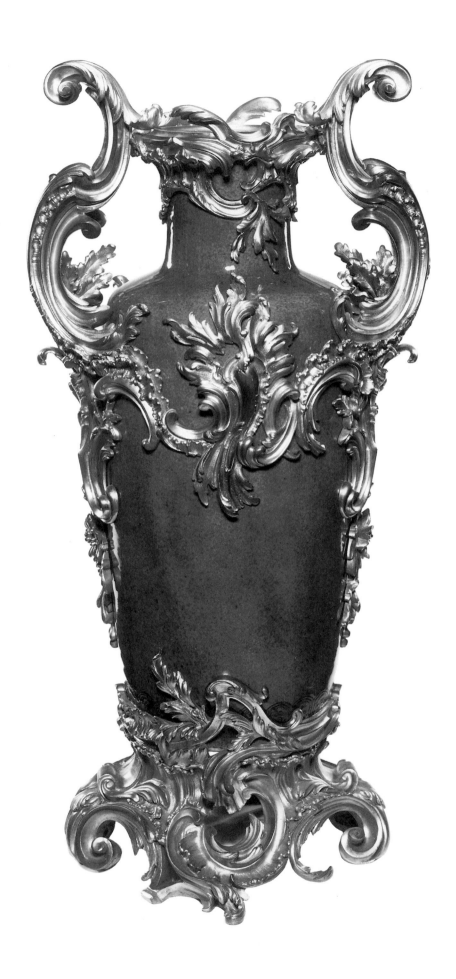

45 Claret Jug or Decanter, Sometimes Known as the Marchioness of Bute's Claret Jug

Porcelain: Chinese, Qing dynasty, 1736–1795
Mounts: English, silver-gilt set with semiprecious stones and enamel, 1870, designed by William Burges (1827–1884)
11 × 4¾ (28 × 12)
Trustees of the Victoria & Albert Museum, London (M22.1972)

This vase, of *sang de boeuf* Chinese porcelain of the Qianlong period, has a globular body and tall flaring neck that is slightly damaged, probably in the course of mounting it. The jug is encased in a silver-gilt network of geometrical design, consisting of straps that are triangular in section and radiate out from quatrefoils at each side. Inset at the main intersections of this cage are semiprecious stones: amethyst, amber, aquamarine, jade, moonstone, and topaz, among others, some over foil. The neck is encased in silver-gilt "window openings" of gothic design below a band of scrolls and foliations. The hinged lid, pierced with quadrilobes, is mounted with a knob formed of Chinese dress ornaments of coral in the form of grotesque animals. The interior of the lid is enameled in three colors with a hexifoil enclosing a lion holding in its mouth Burges's personal device: a flagon containing a flower over flames.

The whole rests on a low splayed foot of silver-gilt enameled in two colors. An inscription in gothic lettering that reads, "WILLIEMUS: BURGES : EX LIBRO : SUO : ANO : DNI : MDCCCLXX," encircles the foot on a green enameled ground.

This claret decanter was designed by William Burges, the well-known Victorian architect, for his own use. A sheet of drawings for the jug, inscribed "William Burges July 2nd. 1867," is in the library of the Royal Institute of British Architects in London. At his death, Burges left a choice of his works of art to his principal patrons, the Marquis and Marchioness of Bute. Lady Bute chose the decanter. It was sold at Christie's, London, by the Hon. Richard Bingham, 18 July 1968, lot 249 (illustrated, pl. 3). It was later in the Handley Read collection, London.

This object is noteworthy because it is almost certainly the last attempt to set oriental porcelain in a European mount of contemporary design, following in the great tradition extending from the late Middle Ages to the end of the eighteenth century. Soon after this decanter was created, firms like A. Beurdeley & Cie. of Paris and others began to make copies and pastiches (see description, cat. no. 44) of eighteenth-century mounted oriental porcelain. None of them tried to create mountings in a new and contemporary idiom.

LITERATURE: R.P. Pullan, ed., *The Designs of William Burges, R.A.* (London, 1885), pl. 19; J. Mordaunt Crook, *William Burges and the High Victorian Dream* (London, 1981), p. 315, fig. 244.

EXHIBITIONS: London, Victoria & Albert Museum, 1952, *An Exhibition of Victorian and Edwardian Decorative Arts*, cat. no. J8, p. 54.

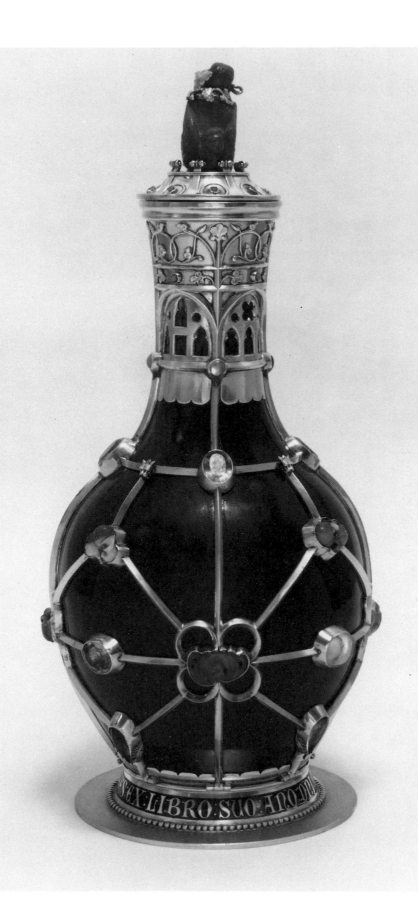

Illustrations, Graphic & Literary, of Fonthill Abbey, Wiltshire, by J. Britton, F.S.A. & C.

(Shaftesbury & London, 1823)
13 × 10 (33.8 × 25.5)
viii plus 76 pages plus 11 illustrations, 3 in color
Chen Huan Esq.

The book is displayed open at the engraved title page, which shows in the Gothic niche at the left the so-called Gaignières-Beckford vase (see Introduction) as it was displayed at Fonthill Abbey when it was in the possession of the great English collector William Beckford. It consists of a white vase of Chinese porcelain of the Yuan dynasty with undercut floral decorations in relief and mounted in silver-gilt and enamel.

There is some reason to suppose the vase itself was originally a present to Pope Benedict XII in 1338. The mounts were probably of Hungarian workmanship, for the arms, which are of translucent enamel, show that it later belonged to King Louis the Great of Hungary (1326–1382). Two other shields attached to the neckband bear the arms of Charles III of Naples (d. 1386) and his successor

Ladislas (d. 1414), both sons of Louis the Great of Hungary, one of the most famous early collectors of Chinese porcelain. The engraving shows the vase before its mounts were removed in the second half of the nineteenth century.

In the corresponding Gothic niche at the right is the so-called Rubens vase, one of the greatest treasures of the Walters Art Gallery in Baltimore. Between them in the central niche is displayed a famous Limoges enamel *chasse* with scenes of the murder of St. Thomas à Becket in Canterbury cathedral, now in The Metropolitan Museum of Art, New York. All three works of art belonged to Beckford.

The cathedral binding of the copy of *Illustrations* is said to have been specially made for Beckford to present to a friend.

Illustrations,
Graphic & Literary,
of
FONTHILL ABBEY
Wiltshire.
by
J. Britton.
F.S.A.
&c.

Engraved by J. LE KEUX. ⸺ Designed by J. BRITTON. ⸺ Drawn by S. RAYNER.

ARCHITECTURAL & HERALDICAL TITLE
FOR
BRITTON'S ILLUSTRATIONS OF FONTHILL ABBEY.

(Vide description.)

London, Published by the Author. April 1, 1823.

Drawing for a Chinese Vase Mounted as a Candlestick

Perhaps mid-eighteenth century
Attributed to François d'Orbay (1634–1697)
Pencil and brown wash on gray washed paper
$8\frac{1}{2} \times 6$ (21.7 × 15.3)
Kunstbibliothek Berlin mit Museum für Architektur,
Modebild, und Grafik-Design, SMPK (OZ 81)

In this study, taken from a page in a sketchbook, the candlestick at the left appears to be formed from a vase of oriental porcelain, mounted around the neck with two masks from which swags of fruit or flowers depend. A drip pan and candle socket, apparently of gilt bronze, emerge from the narrow mouth of the vase. This design is not necessarily one for mounting oriental porcelain but rather the record of a piece seen by the artist and perhaps intended as a guide or record for the use of artisans.

In the catalogue of the French decorative drawings in the Kunst-bibliothek Berlin, this drawing is attributed to François d'Orbay. The design of the candlestick, however, appears to date from much later, for it is in the neoclassic style.[1]

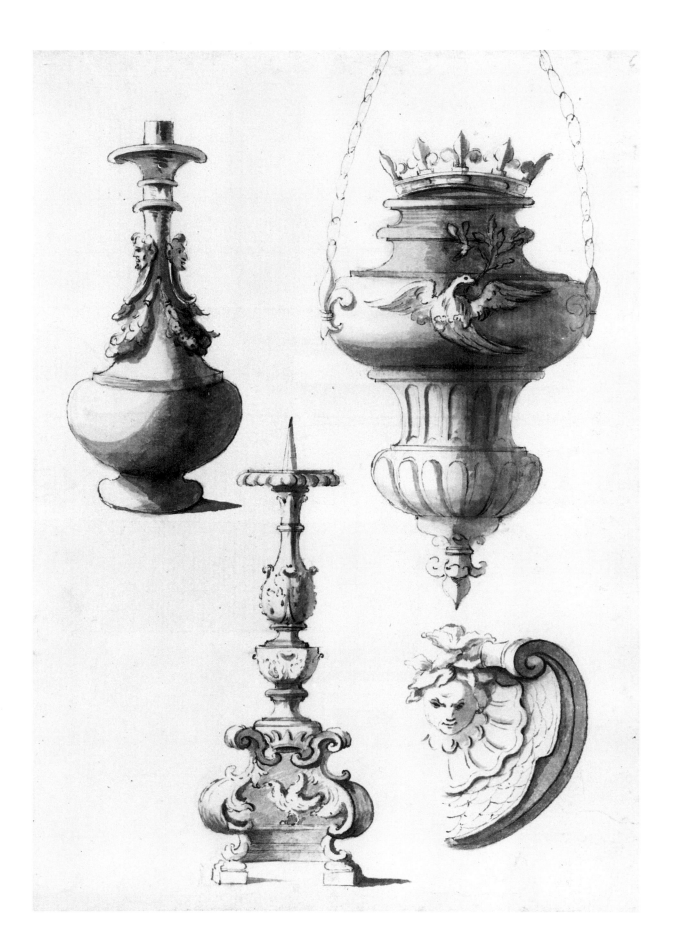

48 *Drawing for Two Mounted Vases of Chinese Porcelain*

Uncertain date, possibly c. 1760 to 1775, but perhaps later
Attributed to Jean-Claude Duplessis (c. 1703[?]–1774)
Watercolor over pencil and ink on paper
7 × 8¼ (17.7 × 21)
Kunstbibliothek Berlin mit Museum für Architektur,
Modebild, und Grafik-Design, SMPK (Hdz 42)

The drawing at the left shows a tapering vase of dark blue porcelain mounted around the shoulder with two scroll handles on each of which a Chinese figure sits. The drawing at the right shows a trumpet-shaped vase mounted with two handles in the form of chimeras with goat heads and horns, their winged bodies terminating in a snake entwined in a spiral around the body of the vase.

In the catalogue of the French decorative and architectural drawings in the Kunstbibliothek Berlin,[1] the drawing is attributed to Jean-Claude Duplessis, who is known to have designed and made mounts for porcelain and furniture. The style, however, seems closer to that of the neoclassic architect Charles de Wailly (1729–1798), although like so many drawings for the decorative arts it is likely to remain anonymous in the current state of knowledge.

49 *Large Celadon Vase with Incised Decoration Mounted with Two Handles, a Lip, Animal Masks, and a Complex Foot of Gilt Bronze*

c. 1770–1785
Watercolor on paper
9³⁄₁₆ × 14⁷⁄₈ (23.4 × 37.8)
The Metropolitan Museum of Art, New York City, gift of Ralph Esmerian (61.680.1[7])

50 *Four Celadon Vases Mounted with Gilt Bronze, Two of Them Conjoined to Form a Potpourri*

c. 1770–1785
Watercolor on paper
9³⁄₁₆ × 14⁷⁄₈ (23.4 × 37.8)
The Metropolitan Museum of Art, New York City, gift of Ralph Esmerian (61.680.1[8])

51 *Large Gray Crackle Celadon Vase Mounted with Two Tall Handles of Gilt Bronze and the Outline of Other Vases, One Mounted in the Neoclassic Style, and Two Others without Mounts*

c. 1770–1785
Watercolor and black chalk on paper
9³⁄₁₆ × 14⁷⁄₈ (23.4 × 37.8)
The Metropolitan Museum of Art, New York City, gift of Ralph Esmerian (61.680.1[10])

52 *Five Vases of Chinese Porcelain, One Mounted in the Neoclassic Style, Perhaps as a Potpourri*

c. 1780–1792
Watercolor, black chalk, and gray ink on paper
9³⁄₁₆ × 14⁷⁄₈ (23.4 × 37.8)
The Metropolitan Museum of Art, New York City, gift of Ralph Esmerian (61.680.1[18])

These four drawings form part of a large group that includes drawings of porcelain-mounted furniture and other decorative objects. Certain of the drawings (but not those included here) are inscribed with the names of Duke Albert of Saschen-Teschen and his wife Marie-Christina, a sister of Marie Antoinette, joint governors of the Netherlands from 1780–1792. The couple is known to have acquired French furniture during a visit to Paris and to have been presented with porcelain by the queen.

It has been suggested that works like this group of drawings, which were sent out by the *marchand-mercier* Philippe Poirier from his shop, A la Couronne d'Or, in the rue Saint-Honoré in Paris, are the eighteenth-century version of today's mail-order catalogues. Poirier had a virtual monopoly in selling furniture mounted with Sèvres porcelain of the type illustrated.[1]

But the unfinished character of some of the drawings seems rather to support an alternative view that they form an incomplete catalogue or illustrated inventory of the contents of the palace of Laeken in Brussels, which was built for the Saschen-Teschens between 1785 and 1792, during their tenure as governors of the Netherlands.

The vase in cat. no. 49 resembles cat. no. 33, and the vase in cat. no. 51, although of a different shape, is of the same rare gray crackle porcelain as cat. no. 20, while its mounts resemble closely those of cat. nos. 19 and 33.

Drawing for a Mounted Vase on a Pedestal for the Royal Pavilion, Brighton

c. 1815–1825
Frederick Crace (1779–1859)
Watercolor and graphite on paper
18¾ × 12⅛ (47.8 × 30.8)
Cooper-Hewitt Museum, Smithsonian Institution's National Museum of Design,
New York City, purchased in memory of Mrs. John Innes Kane (1948.40.75)

The design shows a tall trumpet-shaped vase of export porcelain enameled with *famille rose* colors. It has a swollen band midway, and it is mounted with two tall slender handles of gilt bronze, terminating above the mouth of the vase in confronted winged dragons.

The support, of the same height as the vase, is in the form of a two-staged table in the chinoiserie style. Each stage is supported on four columns around which serpents are entwined and is surrounded midway by a Chinese temple roof from which hang tiny bells. Within each stage there is a section cut from a cylindrical porcelain vase similar to the mounted vase above.

This design is one from a large group by Frederick Crace made for Brighton Pavilion, the small Indo-Chinese palace built by the Prince of Wales, later George IV, beside the sea at Brighton in Sussex between 1815

and c. 1822. Many mounted vases of this character and designed by Crace exist both at Brighton today and in the English Royal Collection. None, however, corresponds exactly to this drawing.

Genuine nineteenth-century mounted porcelains (as distinct from pastiches or forgeries of eighteenth-century originals) have an entirely different character from those produced during the previous century. They generally attempt, as here, to imitate the Chinese style and adapt the porcelain to an interior of distinctly Chinese character. The aim in the eighteenth century was entirely different: to adapt oriental porcelain to a European setting. Hence the mounts are entirely Western in design.

Notes

4.

1. Some pieces were on view in "The Treasure Houses of Britain," an exhibition held at the National Gallery of Art in Washington, D.C., 1985–1986, and illustrated in the catalogue of the same title (cat. no. 134, pp. 204–209).

2. See *Catalogue of English Silversmiths' Work*, London, 1920, no. 25.

3. For an illustration, see A. I. Spriggs, "Oriental Porcelain in Western Painting 1450–1700," *Transactions of the Oriental Ceramics Society* 36 (1964–1966): 75, pl. 61a.

5.

1. For illustrations of all three, see plate 22 of the catalogue of an exhibition of Persian and Near Eastern faïence at the Burlington Fine Arts Club in London in 1908.

2. For details, see Arthur Lane, *Later Islamic Pottery, Persia, Syria, Turkey* (London, 1957), p. 59, from which the above references are taken.

6.

1. For an illustration, see Lunsingh Scheurleer 1980, fig. 30.

8.

1. See cat. nos. 16 and 58 in *Interaction in Ceramics, Oriental Porcelain and Delftware*, the catalogue that accompanied the exhibition that was on view in Hong Kong and elsewhere in the Far East in 1984.

9.

1. For illustrations, see Charles Oman, *Caroline Silver*, London, 1970, and Lunsingh Scheurleer 1980, fig. 108.

10.

1. For an illustration, see Lunsingh Scheurleer 1980, fig. 394.

11.

1. For an illustration, see Lunsingh Scheurleer 1980, fig. 489.

15.

1. For an illustration, see Lunsingh Scheurleer 1980, fig. 120.

17.

1. A pair of candelabra resting on terraced bases and with floral arms of gilt bronze. Grotesque figures of old sky-blue porcelain are seated beneath the arms, which are mounted with various flowers of Vincennes porcelain, 264 l[ivres].

2. Two grotesque figures of old white porcelain, each beneath a scrolled arbor of gilt bronze, 300 l[ivres].

19.

1. Two other tall vases of old celadon porcelain, mounted as ewers with chased and gilt bronze, 1680 l[ivres].

2. The gilt-bronze mounts for two Chinese vases fashioned in the form of ewers, 288 l[ivres].

3. See Geneviève Levallet, *La Renaissance de l'Art Français . . .* (Paris, January 1922), pp. 60–67.

4. For a discussion, see Watson 1956, cat. nos. F 113 and F 115.

20.

1. Two vases of gray crackle porcelain in the form of potpourris, mounted with gilt bronze, 1200 l[ivres].

2. For an illustration, see Lunsingh Scheurleer 1980, fig. 307.

3. See Watson, Wilson, and Derham 1982, cat. no. 10.

21.

1. The mounts of gilt bronze for two Chinese porcelain vases, with which to adapt them as ewers, 288 l[ivres].

22.

1. For an illustration, see cat. no. 21 of an exhibition held in 1980–1981 at China House, New York City.

2. Two lidded vases of Turkish blue porcelain, 16½ *pouces* high. They each rest on three tripodal feet, and each has two scrolled handles. The lid is surmounted by a platform ornamented with coral and a kind of conch shell. The pair, with their gilt-bronze mounts, is well wrought and very pleasing.

23.

1. A vase of red lacquer in the form of a potpourri, mounted in gilt bronze.

2. For an illustration, see *The J. Paul Getty Museum Journal* 13 (1985), figs. 12–18.

26.

1. Two monkeys of *terre des Indes*, 96 l[ivres].

2. One monkey of ancient *terre des Indes*, 96 l[ivres].

3. For an illustration, see Nanne Ottema, *Chineesche Ceramiek Handboek . . . in het Museum het Princessehof*, te Leeuwardan, 1946, p. 204, fig. 233.

27.

1. Two unusual shells, their mouths colored a deep red touched with sky blue, fitted with lids irregularly pierced and with a handle of shell form and three feet of rococo design, all of gilt bronze. Height, 6 *pouces*; width, 7 *pouces*.

2. Two handsome lidded shells of fine old celadon porcelain with rims colored in a beautiful deep red; they are of the highest perfection and mounted with gilt bronze.

3. An old Japanese porcelain vase, in the shape of a shell, with a gilt-bronze mount.

4. An old porcelain shell with a crackle glaze, and slightly damaged, mounted in gilt bronze. Price, 36 livres.

5. A large celadon shell-vase with a gilt-bronze mount for 60 louis, 1440 livres.

6. For an illustration, see Lunsingh Scheurleer 1980, fig. 284.

28.

1. H.M. the King: Sent to Compiègne two pairs of small two-branched candelabra with arms of gilt bronze, mounted with Vincennes porcelain flowers of a sky-blue color; beneath them are seated grotesque figures of the same color, 528 l[ivres].

2. The gilt-bronze mounts of two candelabra, adorned with foliate sprays and with terraced bases of gilt bronze on which are seated grotesque pottery figures.

3. For illustrations of a representative selection, see Lunsingh Scheurleer 1980, figs. 369–372 and 386–388.

30.

1. For an illustration, see *Connaissance des Arts* 108 (February 1961): 367ff.

31.

1. A Flemish cottage in the form of a perfume burner decorated with appropriate motifs, figures, and animals, 480 l[ivres].

2. For an illustration, see Lunsingh Scheurleer 1980, fig. 383.

32.

1. Two celadon fish forming pitchers with gilt-bronze mounts, 960 l[ivres].

2. Two celadon fish mounted in gilt bronze as ewers, 1800 l[ivres].

3. For an illustration, see Watson 1980, cat. no. 23.

4. Four irregularly shaped feet of chased gilt bronze for two small vases of brown porcelain and two fish (for Versailles), 42 l[ivres].

34.

1. Two large celadon vases with gilt-bronze mounts by Duplessis, 3000 l[ivres].

2. Two covered celadon urns with gilt-bronze mounts by Duplessis, 2920 l[ivres].

3. The gilt-bronze mounting of two porcelain urns, model expressly made by Duplessis, 960 l[ivres].

4. The gilt-bronze mounting of a celadon baluster-shaped vase having a goat's head, new model by Duplessis, 320 l[ivres].

5. The gilt-bronze mounts of a vase of blue porcelain, paid to M. Duplessis 720 l[ivres]—The gilding of said vase with ormolu, 192 l[ivres].

36.

1. A vase of ancient blue porcelain imitating lapis lazuli, mounted in gilt bronze, 1320 l[ivres].

2. The chased and gilt mount of a blue porcelain vase, paid to M. Duplessis 720 l[ivres]—The ormolu gilding of said vase, 192 l[ivres].

3. Four large vases of blue porcelain with cartouches, 24 louis 576 l[ivres].

4. Have the vases cut and have them mounted with gilt-bronze feet, and with gadrooning around the necks, 216 l[ivres].

5. See Watson 1980, cat. no. 21.

38.

1. Two covered urns of celadon porcelain with pendant handles, mounted on a terraced base, with circlets and lids of gilt bronze, 864 l[ivres].

40.

1. See Watson, Wilson, and Derham 1982, p. 9.

43.

1. For an illustration, see fig. 3 of the catalogue of the exhibition "Chinoiserie und Japonerie," held at the Berlin Museum in 1976.

44.

1. See Watson 1980, cat. no. 25 and 31 and the bibliographical references given there. Those disposed to pursue the matter further should consult David Rosen, "Photomacrographs as Aids in the Study of the Decorative Arts," *Journal of the Walters Art Gallery* XV, XVI (1952–1953): 92–96, and Watson, Wilson, and Derham 1982, cat. no. 18.

47.

1. See Ekhart Berkenhagen *Die Französischen Zeichnungen der Kunstbibliothek Berlin* (Berlin, 1970), p. 119.

48.

1. See Ekhart Berkenhagen, *Die Französischen Ziechnungen der Kunstbibliothek Berlin* (Berlin 1970), pp. 246–247, Hdz 5034.

41–52.

1. See C. C. Dautermann, J. Parker, and E. A. Standen, *Decorative Art from the Samuel H. Kress Collection at the Metropolitan Museum* (New York, 1964) passim.

APPENDICES

A Note on the Methods Used to Mount Porcelain

Metal mounts were attached to porcelain in a variety of ways. Sometimes they were designed simply to clasp the porcelain closely (see cat. nos. 4, 21, 31). With porcelain of certain shapes, such simple mounting was not always possible and other methods had to be adopted. Holes could be drilled through the walls of the porcelain vessel to accommodate lugs attached to the backs of the metal mounts (see cat. no. 39). With finials and handles, such lugs were often threaded and secured on the interior with a screw nut (see the lids of cat. nos. 13, 14, 21). Some sort of glue may have been used on occasion, but contemporary evidence is scanty. When glue has been used to attach such mounts, it is generally found to have been applied in recent times.

Quite often the original oriental porcelain had to be cut to adapt it to European shapes (see cat. nos. 19, 34, 36, 40). This was a difficult procedure and must often have led to cracking and even breakage. For large cutting operations, the method of a bow and diamond or some hard dust such as carborundum was probably adopted. Small projecting elements such as floral reliefs or finials could be removed by scoring with a sharp instrument, bracing the body of the piece with string or similar material, and tapping sharply.

Chinese Dynasties and Imperial Reign Dates

DYNASTY	REIGN TITLE	DATES
Yuan		1279–1368
Ming		1368–1644
	Hongwu (Hung-wu)	1368–1398
	Yongle (Yung-lo)	1403–1424
	Xuande (Hsuan-te)	1426–1435
	Qingdai (Ching-t'ai)	1450–1457
	Chenghua (Ch'eng-hua)	1465–1487
	Hongzhi (Hung-chih)	1488–1505
	Zhengde (Cheng-te)	1506–1521
	Jiajing (Chia-ching)	1522–1566
	Longqing (Lung-ch'ing)	1567–1572
	Wanli (Wan-li)	1573–1619
	Tianqi (T'ien-ch'i)	1621–1627
	Chongzheng (Ch'ung-chen)	1628–1643
Qing (Ch'ing)		1644–1912
	Shunzhi (Shun-chih)	1644–1661
	Kangxi (K'ang-hsi)	1662–1722
	Yongzheng (Yung-cheng)	1723–1735
	Qianlong (Ch'ien-lung)	1736–1795
	Jiaqing (Chia-ch'ing)	1796–1820
	Daoguang (Tao-kuang)	1821–1850

GLOSSARY

Arita: A district in Hizen province, Japan, where porcelain clays were found in a very pure state. From the mid-sixteenth century onward, many small private kilns sprang up there. Much porcelain for export was produced in the Arita district.

Baluster: A vase-shaped support generally used along a balcony or the sides of a staircase. The term is often applied to a vase whose body swells out toward the upper or lower part.

Crowned-C: A mark that has been erroneously interpreted as that of Caffiéri, Cressent, or Colson. But Henry Noçq suggested that it was a hallmark used on bronzes made during the period 5 March 1945 to 4 February 1749. During these years taxes were levied on works made of various base metals that were stamped accordingly: tin, F (for *étain fin*) or CE (for *claire étoffe*), according to the quality; lead, PV (for *premier plomb vieux*). The C on gilt bronze is probably for copper (*cuivre*), of which bronze is an alloy. M. Pierre Verlet later showed that the crowned-C cannot be the mark of a *ciseleur* but must refer to the date of execution.

Cabochon: A style of polishing or simple faceting of precious stones in use in the Middle Ages. It is applied as a description of decorative motifs such as a boss treated in this way.

Celadon: A popular collective term for the color of high-fired porcellaneous wares with blue-green glazes. Silica glazes with iron oxide in suspension reduce in wood-fueled kilns to the characteristic blue-green tones, or oxidize in coal-fueled firing to tones of darker olive. The name given to these glazes is probably taken from the character of the shepherd Céladon in one of the plays founded on the romance *L'Astrée* written by Honoré d'Urfé.

Chasse: A reliquary, generally of architectural form, usually that of a miniature church.

Ciseleur: A chaser of metalwork. When a bronze emerged from the casting process, its surface was rough and had to be finished by chasing, that is, by hammering with tools of various sizes somewhat resembling a small screwdriver or chisel with a circular end. The art of chasing was carried to a high degree of perfection in France in the eighteenth century. By chasing various parts of the surface of a bronze with tools of differing size, great vitality was imparted to the finished object. These parts were sometimes contrasted with areas where the surface was burnished. Chasing was done before the bronze was gilded.

Combed cartilaginous material: A term coined by the late Fiske Kimball to describe an abstract decorative motif frequently found in the high rococo style. It resembles human musculature or gristle with combed striations along the sides of a thin, broken, wavelike border.

Crackelure: A network of irregular cracks in the surface of the glaze, resulting from a difference in the rates of expansion and contraction of the body and the glaze while in the kiln and specifically during the cooling. The effect is found in Chinese ceramics from the Han dynasty onward and was originally produced by accident. Later it was developed deliberately for decorative effect.

Doreur: A gilder: sometimes *doreur en métaux* for one who specialized in gilding silver or bronze.

Ebéniste: An artisan who specialized in veneered furniture or *ébénisterie* (from the fact that ebony was used for the earliest veneered furniture), as distinct from a *menuisier* who specialized in carved furniture.

Faïence: A general term applied to all kinds of glazed pottery.

Famille rose, famille verte: French descriptive terms that were adopted in the mid-nineteenth century when the serious study of oriental porcelain was first undertaken. They bear no relation to Chinese descriptive terms.

Famille rose: A type of decoration of porcelain with opaque enamel colors that range from red to a delicate pink. The color derives from the use of purple of Cassius introduced into China by the Jesuit missionaries about 1685. At first used for enameling on metal, its use for porcelain was first attempted in the early eighteenth century and was perfected in the 1720s under the reign of the Yong-

zheng emperor. These enamels enabled porcelain painters to use graduated tints for the first time and achieve modeling in their painting.

Famille verte: These enamels were introduced earlier than the *famille rose* enamels under the Kangxi emperor. It takes its name from a brilliant transparent green often used in combination with iron red, blue, yellow, and aubergine.

Fleuron: Literally, "a little flower." Generally used of a decorative motif of conventionalized petal form.

Fondeur: A founder or caster of metals, and thus one who casts the bronze mounts for porcelain pieces.

Gadroon: A short rounded fluting or reeding used as a decorative motif, usually along a molding. The fluting is sometimes twisted.

Garniture de Cheminée: A set of ornaments for a chimney piece, generally of porcelain or pottery and usually consisting of three or five pieces. There is no equivalent term in English.

The Hundred Antiques: Symbols much used in the decoration of Chinese (and also Japanese) porcelain. The group includes the Eight Treasures and the Four Treasures representing the four fine arts, as well as wealth, wisdom, aesthetic pleasures, and bodily health. In addition, it includes conventionalized representations of sacrificial vessels, flowers, and animals.

Imari: A European term used to describe the Japanese export porcelain made at Arita, which was exported through the port of Imari from the seventeenth century onward. The decoration typically consists of a dark underglaze blue with red and gold

overglaze enamels, sometimes with touches of turquoise blue and green enamel.

Kakiemon: A type of Japanese porcelain decoration in rich enamel colors, chiefly orange-red, blue-green, and opaque yellow with, less frequently, a violet-blue and aubergine. The subjects are principally flowers, birds, and butterflies with small rocks, arranged in simple uncrowded patterns of markedly Japanese character with skillfully contrived blank spaces. The name derives from its creator, Sakaida Kazayemon, later Kakiemon, who was born at the end of the sixteenth century on the edge of the town of Arita. The style was popular in Europe in the eighteenth century and widely copied especially at Meissen, Chantilly, and Worcester.

Kendi: A Malayan word meaning a water vessel used in Hindu and Buddhist rituals. The squat globular shape of a typical *kendi* with its mammiform spout was essentially a Southeast Asian form, but in the Middle and Near East it was often adapted as a *narghile*, a water pipe or hookah.

Kinrande: A style of decoration of porcelain introduced in the mid-sixteenth century that was so called because it resembled gold brocades. It was made by applying gold leaf on a red, green, yellow, or blue enamel ground and was costly and rare. It was particularly favored by Japanese potters for the decoration of porcelain.

Lachinage: A term used in the late seventeenth and eighteenth century for what is now referred to as "chinoiserie." The latter word did not appear in print until 1848 and did not gain admission to the *Dictionnaire de l'Académie* until 1878.

Magot: A small grotesque figure, a dwarf or a crippled beggar. The term was often applied to small porcelain figures of Chinese, especially of the type with a nodding head.

Menuisier: A member of the subdivision of the class of *charpentiers* (carpenters), or artisans working in wood, who specialized small (*menus*) objects, such as carved furniture and paneling.

Ormoulu: An abbreviation for *bronze doré d'or moulu* or gilt bronze. The bronze was generally gilded by the mercury process in which the gold was ground or powdered (*moulu*) to form an amalgam with the mercury and attached to the bronze by the application of heat. Hence the English term "fire gilding."

Porcelaine de France: A name given by dealers and others to the porcelain produced at the Sèvres factory especially after Louis XV took over financial responsibility for it in 1759. To help the factory, he granted it a monopoly on making porcelain in France, although a few small potteries owned by great noblemen, such as the prince de Condé at Chantilly, were exempted from the restrictions since they did not produce on a commercial scale.

Potiche: A jar or vase. A term applied by the early French students of Chinese ceramics to a broad-shouldered, short-necked vase that tapered toward the foot.

Potpourri: An aromatic composed of a variety of dried sweet-scented spices, flower petals, and herbs. By extension, the word was applied to the vases or vessels in which the aromatics were contained.

Repoussé: Literally, "pushed up." A term used in metalwork, especially

silver, in which decoration in relief has been created by hammering from the back of the sheet metal.

Rocaille: Literally, "a small rock." A favorite decorative motif of the rococo style. The more restricted use of the word came to be applied to the rococo style itself.

Rouleau vase: A tall vase produced in China from the twelfth century onward, with a cylindrical body and narrow, flat shoulders; the neck is low and wide with the mouth flared.

Terre des Indes: A vague term used by dealers and auctioneers in the eighteenth century to describe any faïence of a Far Eastern origin.

Sang de Boeuf: A nineteenth-century French term for the deep red glaze known to the Chinese as *Lang-yao*. It is a brilliant red glaze varying in color from cherry red to a heavy blood red and distinguished from the *flambé* red by the absence of any gray or gray-blue streaks. The glaze was brought to perfection during the reign of the Kangxi emperor, but thereafter the secret seems to have been lost.

Woodwose: A wild man from the woods, a satyr. A mythical figure often represented in medieval art as a semihuman face emerging from, or surrounded by, leaves.

Yen Yen: Literally, "beautiful." A word applied to a baluster-shaped vase with a long, trumpet-shaped neck. Probably a Chinese dealer's term used to cry up his wares.

SELECT BIBLIOGRAPHY

The literature on mounted porcelain is scanty. Apart from the material mentioned in the first (unnumbered) note to the Introduction and the various books and articles mentioned in the notes to the Catalogue, anyone wishing to pursue the study of the subject may find the following sources useful.

de Ricci 1911.
Seymour de Ricci. *A Catalogue of a Collection of Mounted Porcelain Belonging to E. M. Hodgkins*, Paris, 1911. This catalogue illustrates a small but interesting assemblage of eighteenth-century French mounted porcelain, and the brief introduction provides some valuable pioneering information.

Eriksen 1974.
Svend Eriksen. *Early Neo-Classicism in France*, London, 1974. This publication includes some interesting material on the mounted porcelain made during the last third of the eighteenth century.

Hackenbroch 1955.
Yvonne Hackenbroch. "Chinese Porcelain in European Silver Mounts," *The Connoisseur* (June 1955): 22–29 (special Grosvenor House Fair issue). This article is an excellent survey of surviving examples down to the mid-seventeenth century.

Lunsingh Scheurleer 1980.
D. F. Lunsingh Scheurleer. *Chinesisches und Japanisches Porzellan in europäischen Fassungen*, Braunschweig, 1980. This book illustrates a large number of mounted pieces, but the author is primarily interested in the export wares that were mounted rather than in their mounts.

van der Pijl-Ketel 1982.
C. L. van der Pijl-Ketel, ed. *The Ceramic Load of the Witte Leeuw (1613)*, Amsterdam, 1982.

Volker 1952.
T. Volker. *Porcelain and the Dutch East India Company*, Leiden, 1952. This volume gives valuable information on the Dutch trade in porcelain with China and Japan.

Watson 1956.
F. J. B. Watson. *Wallace Collection Catalogue of Furniture*, London 1956.

Watson 1970.
F. J. B. Watson. *Catalogue of the Charles B. Wrightsman Collection*, New York, 1970. The introduction to vol. IV, pages 375–391, is particularly useful.

Watson 1980.
F. J. B. Watson. *Chinese Porcelains in European Mounts*, New York, 1980; pages 10–22 of the introduction contain the pertinent information.

Watson, Wilson, and Derham 1982.
F. J. B. Watson, Gillian Wilson, and Anthony Derham. *Mounted Oriental Porcelain in the J. Paul Getty Museum*, Malibu, California, 1982. Once again, the introduction, pages 1–18, is informative.

On the impact of China on European thought in the seventeenth and eighteenth centuries, the following surveys are valuable.

Honour 1961.
Hugh Honour. *Chinoiserie: The Vision of Cathay*, London, 1961.

Reichwein 1968.
Adolph Reichwein. *China and Europe: Intellectual and Artistic Contacts in the Eighteenth Century*, London, 1923; reprint, London, 1968.